The Campus History Series

MOORE COLLEGE OF ART & DESIGN

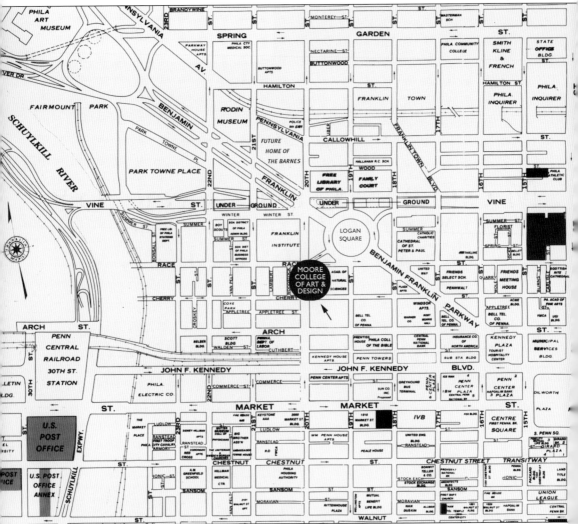

This map shows the location of Moore College of Art & Design and was adapted from a map published in the school's 1981–1983 catalog. Before its move to the Benjamin Franklin Parkway, the school was located at Broad and Master Streets at the old Edwin Forrest Mansion (1880–1959); before that there are several known addresses: first 320 South Third Street, 72 South Walnut Street, Eighth and Locust Streets, Chestnut Street (opposite the U.S. Mint), and Merrick and Filbert Streets (now Broad and Filbert Streets).

On the cover: This image of students of the Philadelphia School of Design for Women (now Moore College of Art & Design) in a fashion illustration classroom was possibly taken in the late 1940s. Along with designing textiles, linoleum, and wallpaper, students at this time found rewarding careers in the fashion industry as designers and illustrators. (Moore College of Art & Design Archives.)

The Campus History Series

MOORE COLLEGE OF ART & DESIGN

SHARON G. HOFFMAN WITH AMANDA M. MOTT

ARCADIA
PUBLISHING

Published by Arcadia Publishing
Charleston SC, Chicago IL, Portsmouth NH, San Francisco CA

Printed in the United States of America

Library of Congress Catalog Card Number: 2007942123

For all general information contact Arcadia Publishing at:
Telephone 843-853-2070
Fax 843-853-0044
E-mail sales@arcadiapublishing.com
For customer service and orders:
Toll-Free 1-888-313-2665

Visit us on the Internet at www.arcadiapublishing.com

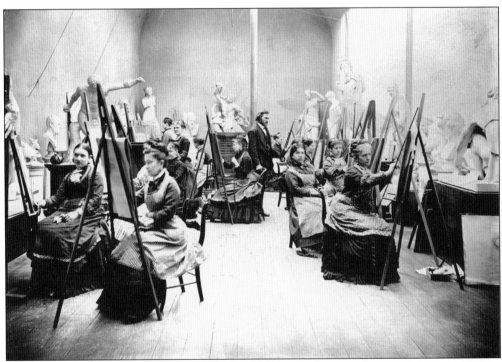

John Moran took this photograph of his brother-in-law, Stephen Ferris, teaching an advanced drawing class in 1875. In addition to teaching, the Ferris and Moran families had deep ties to the school. Stephen Ferris was an etcher and a portrait painter with a well-known collection of prints. John Moran was one of three brothers, all distinguished artists. His brother Peter, who also taught at the school, was president of the Philadelphia's Etching Club.

CONTENTS

ACKNOWLEDGMENTS

Most of the images in this publication are taken from the Moore College of Art & Design Archives. The archives is a testament to the careful guardianship of artwork, correspondence, and documentation over the course of many decades. We are indebted to these unnamed archivists as well as to the caretakers of history at the many institutions that gave us access to their collections.

Particular thanks needs to go to four people whose scholarship and publications were principal resources: Page Talbott, who served as a consultant to the archives and permanent collection at Moore for over 15 years, and Katharine Martinez, who cowrote *Philadelphia's Cultural Landscape: The Sartain Family Legacy*, 2000; Nina de Angeli Walls, author of *Art, Industry, and Women's Education in Philadelphia*, 2001; and Graeme Chalmers's *Women in the Nineteenth-Century Art World: Schools of Art and Design for Women in London and Philadelphia*, 1998.

Gratitude goes to those institutions that graciously gave us permission to use images from their collections and the individuals who shared their expertise. They include John Alviti, senior curator of collections, the Franklin Institute; Linda Wisniewski, print department assistant, Library Company of Philadelphia; Naja Palm, registrar of collections, the African American Museum; R. A. Friedman, Historical Society of Pennsylvania; Barbara Katus, rights and reproductions manager, Pennsylvania Academy of the Fine Arts; Evelyn Taylor, the Kimmel Center for Performing Arts; Sara Hesdon Buehler, collections registrar, James A. Michener Art Museum; Jon Williams, Hagley Museum and Library; Irene Castiglione, permissions, *Harper's Magazine;* Margaret Hofer, curator of decorative arts, New-York Historical Society; Jim O'Donnell, museum specialist at the U.S. Postal Service; Museum of Northern Arizona; Erin Schleigh, Museum of Fine Arts, Boston; and Lizanne Garrett, rights and reproductions coordinator, the National Portrait Gallery, Smithsonian Institution.

Many people at the college helped make this book possible. For their invaluable assistance, we thank the library staff, especially Sharon Watson-Mauro, library director; Jennifer Elliott, archivist; and Erin May Thompson, senior library assistant. A huge debt of gratitude goes to the scanning team of Caitlin "Kitt" Evans '09, Racquel R. James '09, Theresa McGlaughlin '09, Heather Trautz '05, and Jennifer Curcio '09.

Three people deserve special mention for their considerable editorial support. They are Linda Porch, director of development; Kelsey Montague, communications associate; and Irene Cherkassky, public relations coordinator. Appreciation also goes to college president Happy Craven Fernandez and chair of the 160th Anniversary Committee Frances Robertson Graham '66 for their leadership and to Doris Chorney, director of alumnae affairs, and Lynne Jordan Horoschak '66, professor and chair of art education, for their input.

Finally, a word of thanks to Louise Zimmerman Stahl '42, who spent many hours helping us identify photographs. For her tea, company, shared stories, and amazing memory, we are eternally thankful.

INTRODUCTION

I first became aware of Sarah Worthington Peter in 1999 as the president of Moore College of Art & Design. With a background in history, education, and politics, I marvel at what Peter accomplished as a woman living in Philadelphia in the mid-18th century. Her story and the history of the college are powerful evidence that education and art can transform individuals and society. That Peter's school, the first visual arts school for women in the nation, still thrives in the city of Philadelphia after 160 years is an affirmation of the unique mission to educate women for careers in art and design. This long history is also a tribute to the innovations and accomplishments of the school's leaders and graduates that span three centuries.

In 1848, when Sarah Worthington Peter looked out the window of her 320 South Third Street row home in Philadelphia, the scene that greeted her must have been animated and bustling. The house was close to the wharves along the Delaware River. In addition to the cargo and goods arriving in the busy port, there was also a daily stream of new immigrants.

Peter had come to Philadelphia in 1844 to marry William Peter, the British consul to Philadelphia. The Peters would have been expected to provide lodging and hospitality to visitors and dignitaries from abroad. From this vantage point, Sarah Worthington Peter would have been well versed in the political, economic, religious, and social issues of the day. She was active in the Magdalen Society that worked to improve the plight of poor children and women.

The year 1848 was a pivotal year of ferment, change, and innovation in the United States. The founding of Sarah Worthington Peter's school coincided with the first national women's rights convention in Seneca Fall, New York. There Lucretia Mott, Peter's friend and neighbor at 136 North Ninth Street, together with Elizabeth Cady Stanton and Susan B. Anthony, met to adopt the historic Bill of Rights for Women calling for a woman's right to vote.

That same year, Sarah Worthington Peter's "drawing class of some twenty young women, under the instruction of an accomplished teacher" in the living room of the house on Third Street was not a genteel social gathering. Peter had a mission. Deeply concerned about the "deprivation and suffering to which a large and increasing number of deserving women are exposed to" in the city and the lack of opportunity, Peter sought to provide education in the art of design that would give the women a skill and a means of supporting themselves and their families. Her entrepreneurial vision was to bridge the worlds of education and work.

Philadelphia, best known as "the birthplace of democracy," was now emerging as a great industrial city: "the workshop to the world." Home to a booming textile, iron, and printing industry, Philadelphia was feeling the impact of new industrial materials and inventions. At the same time, the expansion of the world's trade routes charted the course for the first and second Industrial Revolution in England, then in the United

States. Mass production and consumption fueled the demand for American decorative design. Peter's new school educated American women as designers of goods for these new industries.

A pioneer in the cause of women's advancement and rights to education and economic equality, Peter was the right person in the right place and time to establish a model for success. Her inspiring legacy continues to this day as Moore College of Art & Design.

This book captures a glimpse of the intervening history of the school, the many "firsts," and the continuing spirit of innovation at Moore. Examples include creating partnerships with industry to offer co-ops or internships for students (1855), developing a normal arts program for art teachers (1858), initiating the Young Artists Workshop to provide art experience for boys and girls (1921), and the first design of a U.S. postage stamp by a woman (1934).

Built on the pioneering vision of Sarah Worthington Peter, Moore College of Art & Design remains an exciting, vibrant educational community where innovation, inspiration, and creativity continue to transform lives and shape the world we share. Today the bachelor of fine arts program for women, as well as the coeducational continuing education programs for youth and adults, prepares students to meet the highest standards in fields of art and design. The Galleries at Moore are internationally recognized as a leader in contemporary art; the Locks Career Center is a visible symbol of Moore's continuing commitment to educate women for careers in the visual arts; and the Art Shop is the only one of its kind in the nation to sell the work of female students and alumnae.

In the summer of 2009, Moore's commitment to innovation will continue with the launch of its first graduate programs: three programs that are coeducational and are unique in the nation. As Philadelphia enters a new renaissance as an international city with rich cultural and educational resources, Moore College of Art & Design celebrates its 160-year legacy and is poised to embrace the future and to be a leader in the emerging creative economy.

Happy Craven Fernandez, Ed.D.
President, Moore College of Art & Design

One

PIONEERS OF CHANGE

In 1848, Sarah Worthington Peter founded Moore College of Art & Design as the Philadelphia School of Design for Women, the nation's first—and today the only—women's college of art and design. After moving to Philadelphia to marry William Peter, the British consul, she became familiar with London's Female School of Design, established in 1842. Peter's vision for an American school to educate women to earn a living in the industrial and design arts was realized in 1848. Peter's school spawned design schools for women in New York, Boston, and St. Louis. The daughter of U.S. senator and Ohio governor Thomas Worthington and Eleanor van Swearington, Peter died in 1877. Writing of her friend's death, Lucretia Mott, who had led the charge of women's rights at the Seneca Falls Conference, acknowledged Peter as a pioneer of women's education. In 1854, Charles Bullett completed this marble bust of Peter, now in the Cincinnati Art Museum.

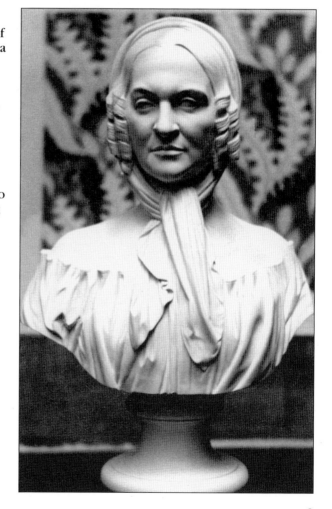

Sarah Peter initially operated the Philadelphia School of Design for Women from her home. By 1850, however, the school's popularity led Peter to seek broader management and support. In a letter to Samuel Merrick, president of the Franklin Institute, she appealed to the board's philanthropic and economic interests, noting the benefits for students and industrial manufacturers of Philadelphia, who needed original designs that could compete with the European market.

1 Invoice designed by a student in 1851

The Early History of the Philadelphia School of Design for Women 241

In 1850, attracted to the idea of educating women for new roles in the emerging industrial nation, the Franklin Institute's board supported Peter's school. The School of Design of the Franklin Institute was managed by a committee of three men and three "lady managers." By 1853, Sarah Peter wanted more say over operations. The Franklin Institute ended the arrangement, and the Philadelphia School of Design for Women was incorporated.

Sarah Josepha Hale, a friend of Sarah Peter and editor of *Godey's Lady's Book*, served with Peter on the board of lady managers in the 1850s. A mother of five, Hale lived an unconventional life as a writer and editor. *Godey's* was so popular in the 19th century that women formed clubs to subscribe as a group. Hale raised the editorial content of the magazine by introducing readers to Henry Wadsworth Longfellow, Ralph Waldo Emerson, and Edgar Allan Poe. The publication had tremendous influence, dictating fashion and literature of the day. Other lady managers included illustrator and naturalist Helen Lawson and Margaretta Hare Morris, an illustrator and the first woman admitted into the Academy of Natural Sciences. This board no longer existed by 1862. Hale hired graduates of the Philadelphia School of Design for Women to color and engrave fashion plates for *Godey's*. Devoted to the cause of women's education, Hale guaranteed free advertising in the magazine to schools for women. She helped found Vassar College and founded the Women's Medical College of Philadelphia. She is also credited with writing the popular nursery rhyme "Mary Had a Little Lamb."

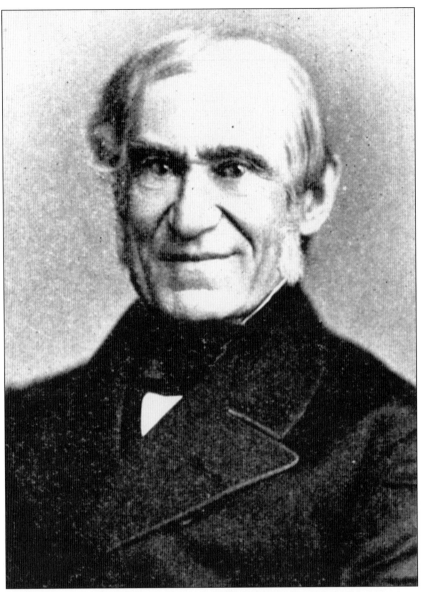

Industrial support was the key to the school's success. David S. Brown, a merchant banker and executive in the textile industry, was president of the school's board from 1872 to 1877. A member of the school's first board under the Franklin Institute, Brown remained loyal after the split. He hired graduates of the school to work in his textile mills and ironworks. In 1862, Brown wrote to principal Thomas Braidwood praising a graduate hired to design calico prints: "We would not exchange her for any male designer we have ever employed." Brown's daughter, Mary Johnson Brown, attended the school and later married Samuel Chew. Mary Brown Chew was an important preservationist of her day as a guardian of both Stenton Hall and Cliveden in Philadelphia and a force in restoring Independence Hall. Today members of Moore's board continue to play a vital role in fulfilling the school's mission under the leadership of president of the board of managers Jack Donnelly, president and chief executive officer of L. F. Driscoll Company, and president of the board of trustees Penny Fox.

12

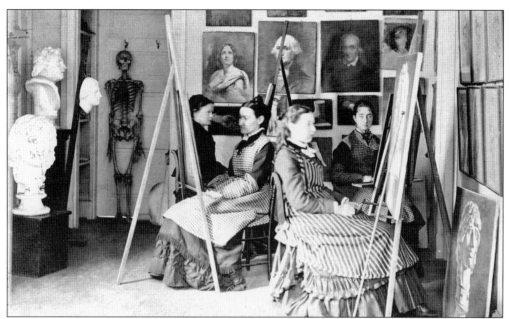

This photograph was taken in 1886, near the end of Thomas Braidwood's tenure as principal. A successful Scottish textile designer, Braidwood favored the English and European methods of teaching "drawing from the flat" and emphasized practical training. In the 1860s, he introduced teacher training into the curriculum and secured funds from the Commonwealth of Pennsylvania's public education budget. Between 1865 and 1868, Braidwood helped establish sister schools in Pittsburgh, Wilkes-Barre, and Scranton.

Administrative Heads of School

1850–1852	Anne Hill, prinicpal
1855–1873	Thomas Braidwood, principal
1873–1886	Elizabeth Croasdale, principal
1886–1920	Emily Sartain, principal
1920–1946	Harriet Sartain, dean
1947–1963	Harold Rice, president
1964–1975	Mayo Brice, president
1975–1976	Mellicent Brown Allen, acting president
1977–1981	Herbert Burgart, president
1981–1990	Edward McGuire, president
1990–1991	John van Ness, acting president
1991–1993	Mary-Linda Sorber Merriam, president
1993–1998	Barbara Gillette Price, president
1998–1999	Mary-Linda Merriam Armacost, acting president
1999–	Happy Craven Fernandez, president

It is not clear why the administrative title for the heads of the school changed from principal to dean and then president, but it most likely had to do with the specific duties and the relationship to the governing committees and boards. Harriet Sartain's title is dean, not president. Possibly this relates to the formalization of certificates and degrees offered by the school. When Harold Rice became the first president in 1947, he was the first male administrative head of the school since 1873.

American-born Elizabeth Croasdale, a graduate of Government Art Training School at South Kensington in England, became principal in 1873. She began teaching perspective in 1878. Under her leadership, enrollment rose modestly. Whereas older women comprised the majority of students at the beginning of Croasdale's tenure as principal, her years in office reflected a shift to education for younger women.

ELIZABETH CROASDALE
Principal from 1873 to 1885

In 1885, the board officers solicited additional financial support from Philadelphia's philanthropic public, appealing for subscribers and contributors to offset the cost of tuition. At the time, the annual population was 250 students, with nearly a dozen graduating as teachers of art. While students were not barred from attending for reasons of faith and race, at the time of the letter, most students were Protestant and white.

✳ THE SCHOOL OF DESIGN ✳

Philadelphia, May, 1885.

THE PHILADELPHIA SCHOOL OF DESIGN FOR WOMEN, the oldest and best developed institution of the kind in the United States, respectfully calls your attention to its urgent requirements to enable it to meet the increased expenditures consequent upon the growing demand on its resources.

In the construction of its plain, yet well-adapted building, south-west corner of Broad and Master Streets, it assumed a heavy responsibility, which, with its increased current expenses, induces us to solicit aid from those whose means enable them to exercise an influence on the industrial and art education of women.

The School is furnished with a large and efficient corps of teachers, who have been selected with the greatest care, and are in every way thoroughly qualified. This fact, together with the high character of its appliances for teaching art, give it an important place among the institutions of the country.

Its classes of late years have averaged about two hundred and fifty pupils, whose studies have covered a very wide field. Its graduates, numbering ten or twelve yearly, are limited to those who have taken a complete course to fit them for the profession of teachers of art. Its scope of studies includes, in addition to thorough instruction in elementary drawing and perspective, landscape in color, sketching from nature and composition, painting from life in oil and water colors, wood engraving, etching, china decorating, flower painting, modeling, lithography, designing for carpets, wall papers, upholstery goods, &c.

The School was never intended to be self-supporting, hence the low price of tuition; for this reason it has always depended to some extent on the aid of public-minded citizens to carry out its purpose of instructing young women in a knowledge of practical art.

The price of annual subscription has been fixed at $5, that of life membership at $50, and of life scholarship at $1000.

Each contributor is entitled to a ticket of free admission to all exhibitions during the year, and to the annual reception at the close of the school year; and for each additional $5 an extra ticket will be given.

Miss Croasdale, the Principal of the School, is authorized to receive contributions, and will take pleasure in calling upon you. We earnestly hope you will enroll your name upon our list of contributors.

P. P. MORRIS,
President.
JOHN SARTAIN,
Vice-President.
F. O. HORSTMANN,
Secretary and Treasurer.

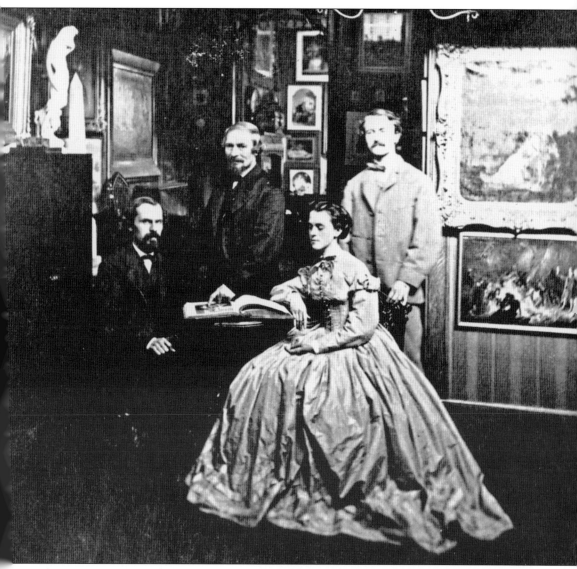

Three generations of the Sartain family helped to shape the Philadelphia School of Design for Women. The patriarch of the family was John Sartain, pictured here in 1865 in his library at 1728 Sansom Street with sons Samuel and William and daughter Emily. John Sartain, a renowned engraver, was famous for bringing the mezzotint process to the United States. The mezzotint popularized the work of well-known painters and helped to democratize art. Elected to the board of directors in 1868, John Sartain was board vice president from 1873 to 1887. John Sartain became a mentor to many artists and writers of his day, including Thomas Eakins and Edgar Allan Poe. Daughter Emily, a talented engraver and portrait painter, was appointed principal of the school in 1886 and served for 33 years, during which time the faculty and school established an international reputation. When Emily retired in 1919, the board appointed Harriet Sartain, who was Emily's niece and John's granddaughter. Harriet had been a student at the school and became the college's first dean. (Pennsylvania Academy of the Fine Arts.)

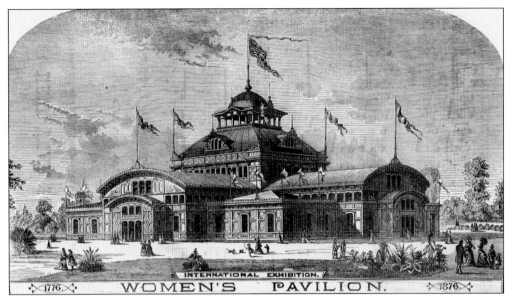

U.S. president Ulysses S. Grant appointed John Sartain chief of the Bureau of Art at Philadelphia's centennial exposition in 1876. Drawing 10 million visitors over six months and placing Philadelphia at the center of the world stage, the centennial introduced new technology and a range of decorative arts. The Women's Pavilion was the first large-scale exhibit of "feminine industry." The school was an exhibitor. This etching is from *Godey's Lady's Book*. (The Library Company of Philadelphia.)

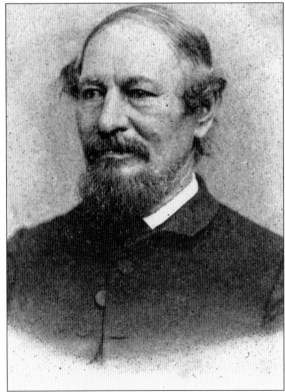

John Sartain's connections to the Philadelphia's art world were far reaching, with ties to the Pennsylvania Academy of the Fine Arts, the Art Union, Artists' Fund Society, and the Freemasons. Co-ops, an early form of internships, were encouraged by leaders of the school and are documented as early as 1851. John Sartain published *Sartain's Magazine* and paid pupils of the school $10 to $15 per week to work for him.

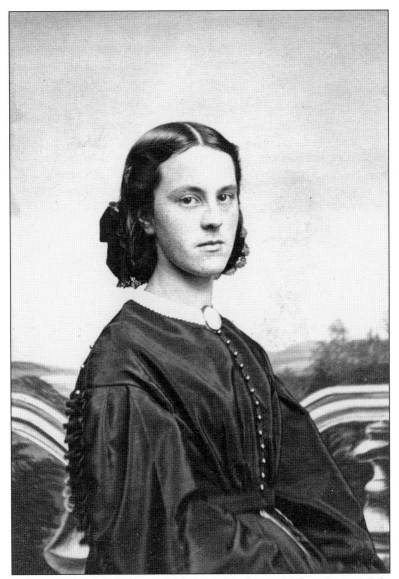

Emily Sartain became the principal of the school in 1886 and served for 33 years (1886–1920). The first woman to practice the art of mezzotint, she was the only woman to win a medal at the 1876 centennial. Sartain was a talented portrait painter and studied at the Pennsylvania Academy of the Fine Arts. Her role at the school was marked by modernizing curriculum, emphasis on proper student behavior, and a vision for educating women for careers in Philadelphia's booming manufacturing marketplace. She also introduced important faculty members such as Robert Henri, Samuel Murray, and Daniel Gerber. In 1913, she published an article on the "Value of Training in Design for Women" in the *New York Times*. This early photograph of Emily Sartain was taken in 1868. In 1871, she and academy classmate Mary Cassatt traveled to Europe, where Sartain studied painting for four years. Sartain was romantically linked to another academy classmate and family friend, Thomas Eakins. In the 1800s, there were clubs for men artists but none for women. In 1897, Emily Sartain remedied this situation as a founding member of the Plastic Club.

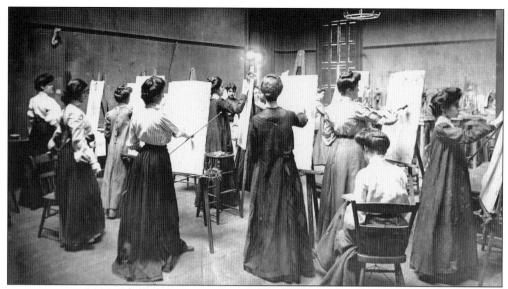

This photograph from 1900 shows a life painting class. Emily Sartain, who had studied in France and Italy, favored new European educational techniques incorporating drawing from nature and life. She felt "drawing from the flat" to be outmoded. Emily helped to raise the profile of the school by promoting the work of its students at world's fairs and hiring instructors of note.

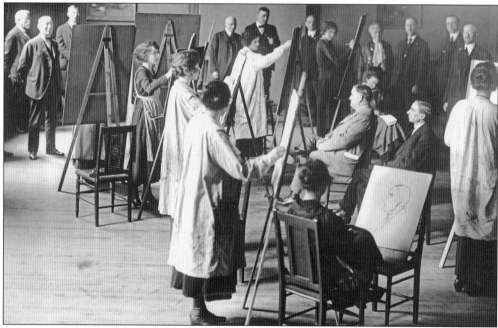

This photograph shows a visit to the school by members of the board and senators in 1918 with Emily Sartain in the back and board president Judge Edwin O. Lewis to her right. Students are sketching Pennsylvania state senator Augustus F. Daix Jr. In 1918, the school was challenged by increased competition, decreased enrollment, and a lobby to terminate state scholarship funding. Under the strain, Sartain's health suffered and she retired in 1919.

Harriet Sartain, class of 1892, led the school for 26 years (1920–1946). An innovator, she increased diversity, introduced evening classes for women who worked during the day, and strengthened the alliance between industry and art. This 1920 photograph of Harriet Sartain appeared in *An Experiment in Training for the Useful and the Beautiful*, written by board member Theodore C. Knauff and published by the school in 1922. The 1920s saw a shift in course enrollment. Students were becoming more interested in commercial arts such as advertising, illustration, and interior design and decorating. The fine arts remained a draw for many, and the school's wide range of courses ensured that all interests were satisfied. When the Commonwealth of Pennsylvania authorized the school to grant a bachelor of science in art education degree in 1931, it was the first academic degree offered by the school. In 1957, Moore's magazine memorialized Harriet as someone who "kept the aims and ideals of art alive in the education of young women. Her contribution to the community, despite the rigor of the times, was courageous, constant, and often filled with self-abnegation."

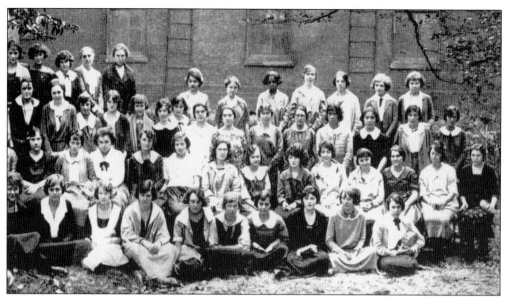

This is a detail from a graduation photograph taken in the Broad and Master Streets courtyard. Anna Jones Russell (1902–1995) was one of the graduates. Russell was the first African American to graduate from the Philadelphia School of Design for Women. A distinguished student—Russell won awards for wallpaper and carpet designs while at the school—she went on to work in rug design and enjoyed a successful career as an artist.

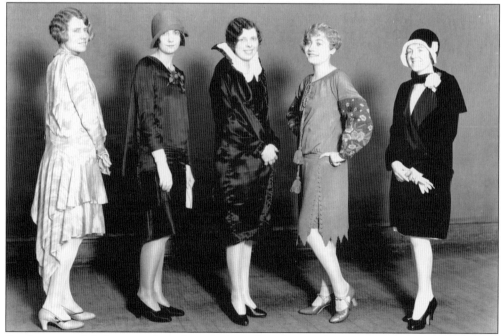

Students model dresses that they designed and sewed in Marguerite Wickersham's evening fashion design class. This photograph appeared in the school's 1929–1930 catalog. Dean Harriet Sartain introduced evening and weekend classes to attract women in the workplace and art teachers.

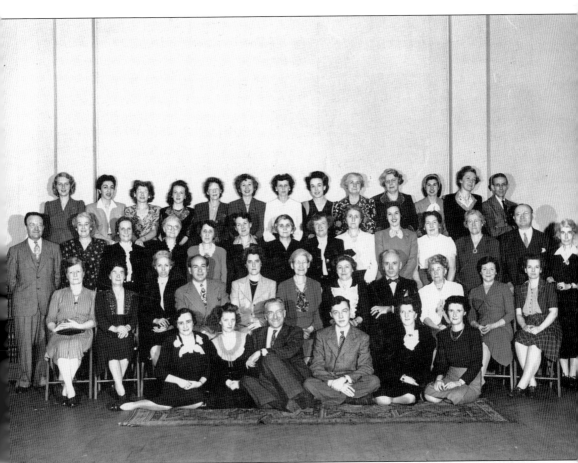

This photograph was taken in 1945, the last year of Harriet Sartain's leadership. At center is Sartain surrounded by faculty, including Elsie Finck, Arthur Meltzer, Frances Coe, Lucille Howard, Paul Domville, Mary Braid Hartman, Emma Buckman, Marion Vogdes, Alfred DiLardi, Paul Nonnest, Margaret Wadsworth, and Sartain's secretary, Elmina Kraus. The school's faculty was, as they are today, working artists and professionals. They serve as mentors in the education of women for careers in art and design. Many are innovators in their own fields. In the early 1930s, the first apparatus for demonstrating the physics of light and color and their effect on form was designed by faculty at Moore. This aspect of color study had never before been explored in art education. Mary Braid Hartman, head of the Design Department, promoted the idea, and two teachers designed and built what was called the color light booth. Louise Zimmerman Stahl '42 incorporated this light box into her groundbreaking work in color during her long tenure at Moore. A version of the light box is still in use in a revised form.

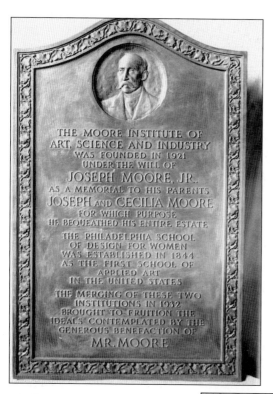

Moore College of Art & Design owes its name to benefactor Joseph Moore Jr., who wanted to honor his parents' memory by funding a "practical women's school." His $3 million endowment founded Moore Institute of Art, Science, and Industry when it merged with the Philadelphia School of Design for Women in 1932. Joseph's brother, Alfred, founded the Moore School of Electrical Engineering, now integrated into the University of Pennsylvania's School of Engineering and Applied Science. This plaque is displayed at the college today.

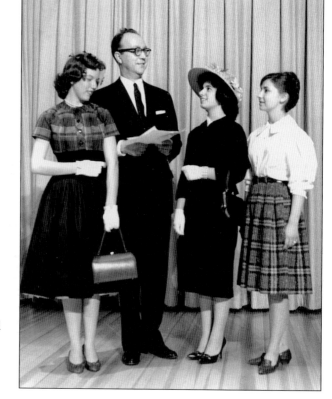

College president Harold Rice is photographed here in 1960 at the annual fashion show. Rice believed the school needed modernization and was instrumental in its move to its current site on the Benjamin Franklin Parkway.

Painter and feminist advocate Judy Chicago is photographed here during a program held at Moore in 1974. Chicago's visit was part of a citywide presentation of Philadelphia Focuses on Women in the Visual Arts. Frieda Fehrenbacher, a former student and a popular instructor at the college, was an organizer and advocate of women's equality. The Fehrenbacher Women's Leadership Fellowship and International Travel Fellowship honor her work in education.

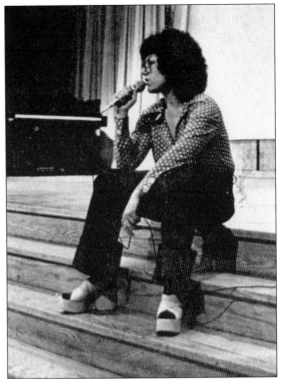

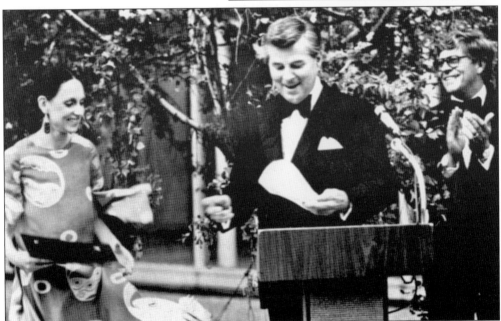

A faculty of working professional artists as well as visiting designers and artists provide career models for students. In this photograph from 1977, fashion designer Mary McFadden receives an Award of Excellence from the president of the Friends of Moore Ronald G. Dowd while college president Herbert Burgart looks on. McFadden was also honored as the 160th anniversary recipient of the Visionary Woman Award in 2008.

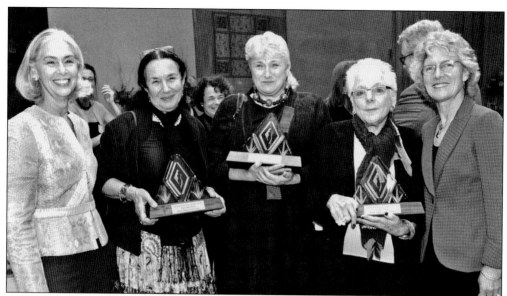

In 2003, the college inaugurated the Visionary Woman Awards to honor women who have had a powerful influence on the visual arts and to raise scholarship funds to educate the next generation of visionary women. From left to right, board member and committee chair Frances R. Graham '66 is shown with the three 2006 awardees, photographer Mary Ellen Mark, arts administrator Thora Jacobson, and feminist art historian Linda Nochlin, and college president Happy Craven Fernandez.

Progress, yes, but still disparity in visual arts.

Top women artists?

Happy Craven Fernandez is president of Moore College of Art & Design

"Why have there been no great women artists?"

Linda Nochlin asked this explosive question in 1971 and changed the study of art history. Then and now, her seminal essay, published in *Art News*, posed a question that still provokes debate.

Do the names Peeters, Neel, Frankenthaler and Lin — all accomplished women artists — trip off your tongue like Van Gogh, Picasso, Eakins and Calder?

If challenged to name the top 10 best-known or contemporary artists, how often would you include a woman on the list?

In a recent survey of the highest paid artists in America, all of the top 20 were men.

On Oct. 19, Moore College of Art & Design, the first and only women's visual-arts college in the nation, honored three artists at the fourth-annual Visionary Women Awards. Groundbreaking feminist art historian Linda Nochlin was one of them. Also honored were Philadelphia-based educator and curator Thora Jacobson and nationally acclaimed photographer and Philadelphia native Mary Ellen Mark.

As president of Moore, I find it tremendously satisfying to recognize the accomplishments of our awardees and the lasting contributions they have made to the visual arts. This year,

however, I've had cause to reconsider the unsettling question posited by Nochlin: Why aren't there more famous women visual artists?

Is it lack of equal opportunity? Is it overt or covert discrimination? Is it because women lack innate ability? Is it rooted in society? How far have we come in the 35 years, and how much further have we to go?

A few statistics may shed light, and there is certainly some good news. According to survey results recently released by the College Art Association, women now hold 64 percent of tenure-track art history positions in higher education, up from 43 percent in 1987-88. According to the Bureau of Labor Statistics, in 2005, 123,084 women were employed as visual artists; that's 52.6 percent of all people employed in the visual arts — up from 47.9 percent in 2002.

In the auction houses, too, there has been some progress. Within the last two years, sales by women artists have broken price records. A work by Agnes Martin sold for $2.6 million, a piece by Joan Mitchell reached the $2.7 million mark, and Marlene Dumas recently sold a piece for $3 million.

However, there is still tremendous disparity. A May 1, 2005, New York Times article, "The X Factor," notes that of the 861 works offered by Christie's, Sotheby's and Phillips de Pury & Co. during their spring contemporary art sales, only 13 percent were by female artists. In those auctions, of the 61 pieces assigned an estimated price

of $1 million, only six were by women.

Sadly, when it comes to solo shows at galleries and museums, women also do not receive as much exposure. Last month, writing for the Village Voice, Jerry Saltz looked at the fall exhibition schedule of 125 New York galleries and reported that, of the 297 solo shows by living artists, only 23 percent are by women. Troubling, too, is that the U.S. Census reports that females continue to earn less than males in all sectors of the visual arts.

Given the existing cultural environment, there is obviously still work to be done.

Clearly, Moore's unique position as an institution that sets the standard of excellence for educating women for careers in art and design takes on greater relevance and importance.

Moore is called not only to bring attention to its Visionary Women awardees, but also to continue to take a leadership role in breaking down barriers, both subtle and overt. Moore is singularly equipped to shape an environment that more equitably showcases, values and benefits from the talents of women visual artists.

We must all — educators, journalists, business and political leaders, curators and collectors — continue to challenge ourselves to be consciously inclusive, or risk missing the next great woman artist.

Contact Happy Craven Fernandez at hfernandez@moore.edu.

In October 2006, Dr. Happy Craven Fernandez, president of Moore, wrote an editorial published in the *Philadelphia Inquirer*. Referencing Linda Nochlin's 1971 seminal, controversial essay, "Why Have There Been No Great Women Artists?" Fernandez asked, "Do the names of artists Peeters, Neel, Frankenthaler and Lin — all accomplished women artists — trip off your tongue like Van Gogh, Picasso, Eakins and Calder?" Fernandez was the first woman to run for mayor of Philadelphia.

Two

A Place to Call Home

Moore's Wilson Hall lights up the night sky in this 2004 photograph. The college moved to its current location at Twentieth Street and the Benjamin Franklin Parkway in 1959. Today the bachelor of fine arts degree program for women enrolls more than 500 students, with 37 percent of all students living on campus in two residence halls. Sarah Peter Hall, visible at the far right, is named for founder Sarah Peter, from whose home the school originally operated. The school moved several times before settling on the Benjamin Franklin Parkway, at the heart of Philadelphia's Museum District. The school's name changed five times during its history: Philadelphia School of Design for Women (1848–1850, 1853–1932), Franklin Institute School of Design for Women (1850–1853), Moore Institute of Art, Science, and Industry (1932–1963), Moore College of Art (1963–1989), and finally Moore College of Art & Design in 1989.

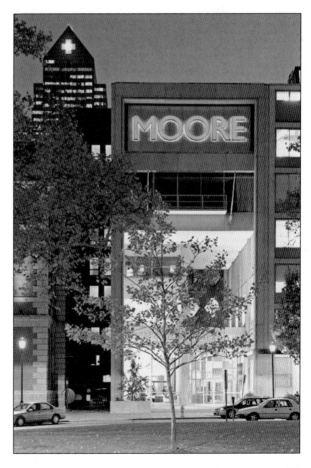

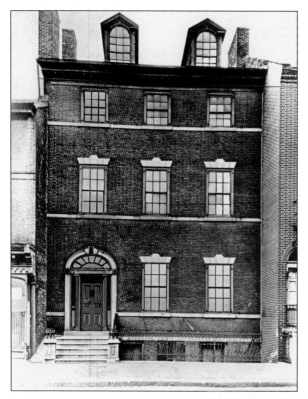

Moore's first location was in Sarah Peter's home at 320 South Third Street in Society Hill, where she held drawing classes in her living room. The building was razed in 1938. By the 19th century, the city had moved westward. By the 1930s, many Society Hill buildings were derelict. A revitalization project helped restore the area in the 1960s, and today it is again one of the city's most sought-after neighborhoods.

By 1863, the school's finances were secure enough to purchase a building. The school bought and improved the Collins property at the corner of Broad and Filbert Streets. When the Pennsylvania Railroad decided to build its Broad Street station on this site, the building was purchased for $37,000. The board used the money to buy the fashionable Forrest mansion on North Broad Street.

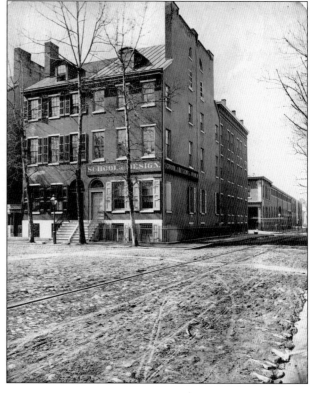

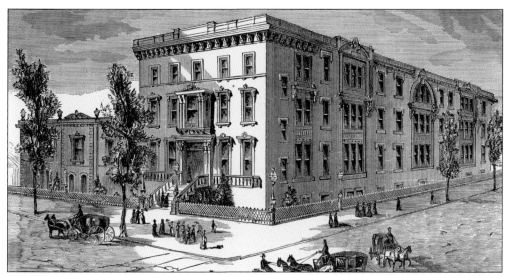

Built in 1854 for William Gaul, a wealthy brewer, the mansion was acquired by acclaimed actor Edwin Forrest in 1855. At the southwest corner of Broad and Master Streets, the brownstone Italianate villa made an elegant, spacious, and convenient new home for the school. This *c.* 1885 engraving shows one of three additions built to create the necessary space and an enclosed courtyard with ventilated balconies for etching classes. In 1880, the board paid $45,000 for the mansion. Alterations and repairs brought the final cost to $103,000.

The Philadelphia School of Design for Women moved to the Edwin Forrest Mansion at Broad and Master Streets in 1880. After renovations and building extensions, the mansion offered roomy and gracious space for classrooms, exhibitions, and socializing. This photograph, taken in 1937 or 1938, shows the Broad and Master location after the school's merger with Moore Institute of Art, Science, and Industry in 1932. Today the Forrest mansion is home to Freedom Theatre.

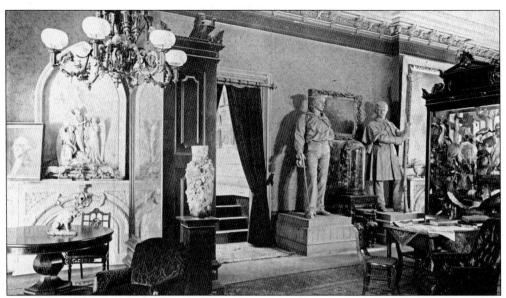

Formerly the reception room and library of Edwin Forrest's home, this spacious room served as John Sartain's office in 1896 at the time this picture was taken. A private gallery beckons from behind the curtained doorway. When Emily Sartain became principal in 1886, she and her parents took up residence in the mansion. This room became the main office of the school sometime before 1919. The Forrest Theater on Walnut Street was named for Edwin Forrest, well known in his time as a champion of actors' rights and small theaters.

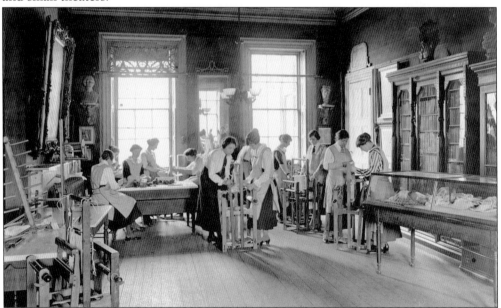

Women are shown here taking a weaving class in 1919 using portable looms. Rooms were used for multiple purposes, so the looms had to be moveable to accommodate the use of the room by other classes. These windows look out onto Broad Street. Textile design was the first bachelor of fine arts degree offered by the school and is one of 10 bachelor of fine arts degrees conferred by the college today.

The school's home at Broad and Master Streets boasted a lovely courtyard that was employed for outdoor sketching, graduation festivities, and fashion shows. Students are shown here wearing original creations that were designed and constructed in the Fashion Arts Department in 1923. Behind the students can be seen a rare bald cypress tree, the largest in the state of Pennsylvania. The columns were moved to the courtyard when the Harrah mansion was demolished to make way for the new Metropolitan Opera House on North Broad Street.

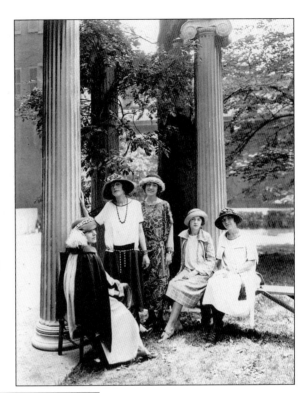

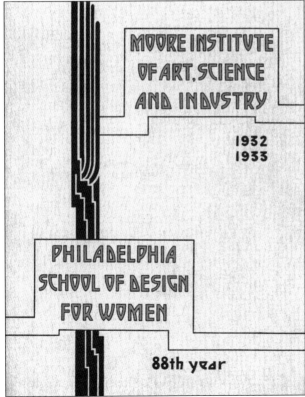

MOORE INSTITUTE
OF ART, SCIENCE
AND INDUSTRY

1932
1933

PHILADELPHIA
SCHOOL OF DESIGN
FOR WOMEN

88th year

This catalog cover was the first to include the dual-named school. The name change occurred because of a $3 million bequest by Joseph Moore Jr. The school was not forgetting its past by accepting the bequest and the name change. The catalog proudly proclaims that the 1932–1933 school year was its 88th.

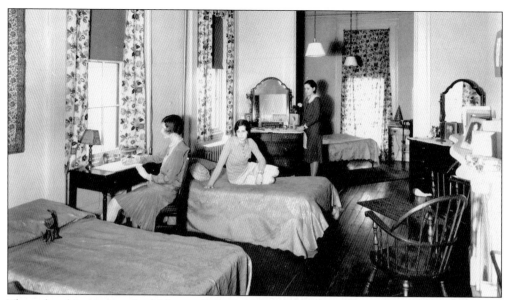

The school introduced residence halls in the 1930s. Board president Judge Edwin O. Lewis bought two row houses in the 1900 block of Race Street to encourage the continued increase in enrollment of students who did not live in the area. This photograph from 1930 shows a dormitory bedroom. The residence hall also had reception rooms and a formal dining room. In 1925, the school also introduced a cafeteria at the Broad and Master Streets location.

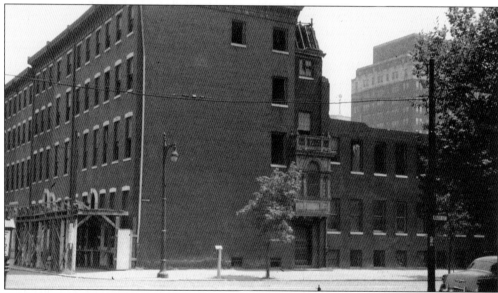

Anticipating the move to the Benjamin Franklin Parkway, Lewis purchased the Race Street buildings, shown in this 1940s photograph, and other properties in the area. Moore needed to expand, and the dormitories' Benjamin Franklin Parkway location was closer to Philadelphia's premier cultural attractions. Taxis would idle outside the dormitories to whisk students to their classes at Broad and Master. The Race Street residences were demolished in the 1950s to make room for the new campus on the Benjamin Franklin Parkway.

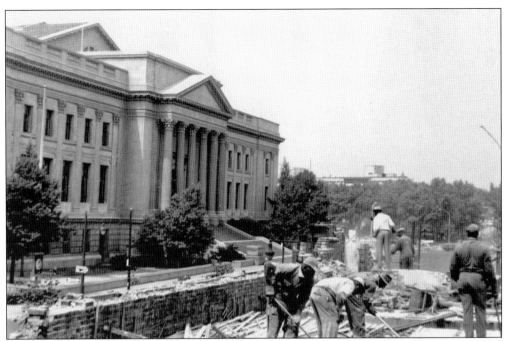

Construction workers begin to raze the old dormitories at Twentieth and Race Streets to make way for the new college building on the Benjamin Franklin Parkway. On the left, the facade of the Franklin Institute can be seen. The school had experienced an early alliance with the Franklin Institute from 1850 to 1853. During those years, the Franklin Institute took over the financial management of the school.

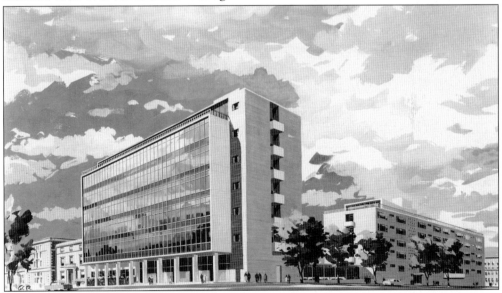

This architect's drawing from 1959 renders the exterior of Moore Institute of Art, Science and Industry on the Benjamin Franklin Parkway at Logan Square. The new residence halls, completed in 1957, are seen to the far right of the image, and Sarah Peter Hall stands seven stories tall at the center. By 1958, all full-time students were enrolled in degree programs replacing the school's earlier certificate and diploma programs.

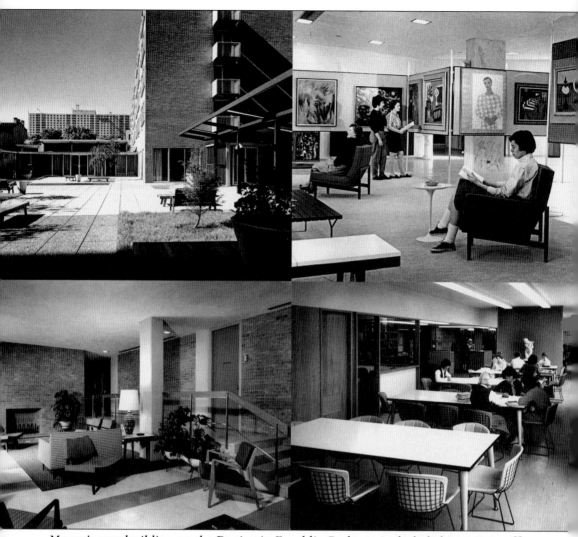

Moore's new building on the Benjamin Franklin Parkway included classrooms, offices, gallery space, an auditorium, a dining and residence hall, and a lounge and library. The new campus on the Benjamin Franklin Parkway was organized around a courtyard, much like the previous location at Broad and Master Streets. Subsequent renovations and additions have altered the courtyard pictured in the top left frame of this publicity photograph from 1962. The campus included the main residence hall (now Stahl Residence Hall), which faces Twentieth Street, shown here to the right of the courtyard. The student lounge on the first floor of the residence hall is shown at lower left. The lounge space today has a fully accessible entrance and conference room. The images on the right show the gallery space on the first floor and the library on the third floor of Sarah Peter Hall. In the early 1960s, the new building attracted a record number of applicants. By 1964, the school enrollment had grown to 400.

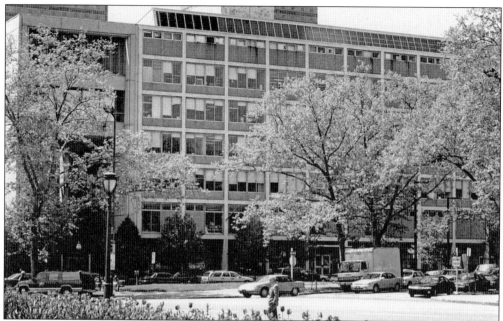

In 1996, the college acquired the ASTM building, far left, adjacent to Sarah Peter Hall on Race Street. Built in 1963, the award-winning contemporary building was designed by architects Carroll, Grisdale and Van Alen. The architects used an innovative column-free structure. This photograph was taken by Sharon Wohlmuth '75 for the college magazine. ASTM was renovated and opened as Wilson Hall in 2000.

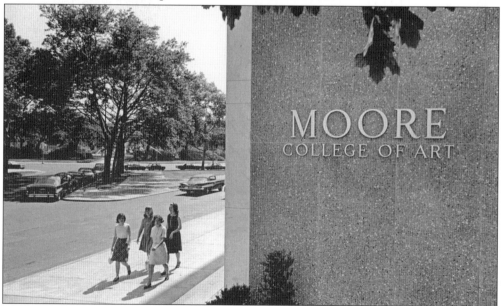

Taken from the southeast corner of Twentieth and Race Streets, this 1960s photograph shows Aviator Park before the street bisecting the park was closed. Today it is the site of the Moore Sculpture Park. A $1.5 million enhancement project in 2007 provided additional paving, lighting, and seating. Note the name of the school: Moore College of Art was renamed Moore College of Art & Design in 1989.

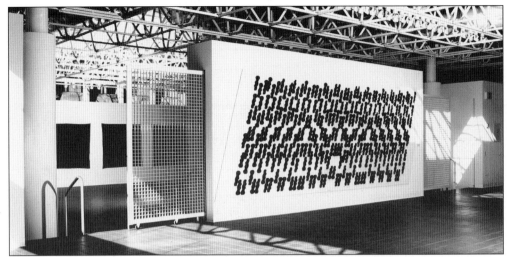

The 1980s were years of expansion for the Galleries at Moore. The new Goldie Paley Gallery was dedicated at Moore in 1984. In 1987, a gift from painter Rochelle "Cissie" Levy '79 combined with the Paley gift, and a grant from the William Penn Foundation financed an expansion and endowed a directorship at the Galleries. The gallery expansion designed by Karen Daroff '70, president of Daroff Design, Inc., was featured in *Interiors* magazine. The plan created two large exhibition spaces around an enclosed multipurpose atrium. The Levy Gallery for the Arts in Philadelphia, pictured above, and renovated Paley Gallery opened in 1987. Below, Rochelle Levy and her husband, Robert P. Levy, perform the ribbon cutting. Gallery director at the time, Elsa Longhauser brought international visibility to the Galleries at Moore and established their reputation for cutting-edge exhibitions. Other galleries at the school honor generous donors: the Graham Gallery for Frances Robertson Graham '66, the Widener Memorial Foundation Gallery for Fitz Eugene Dixon Jr., who until his death in 2006 was president of the Widener Foundation, and the Wilson Gallery, named for board chair emerita Penelope P. Wilson.

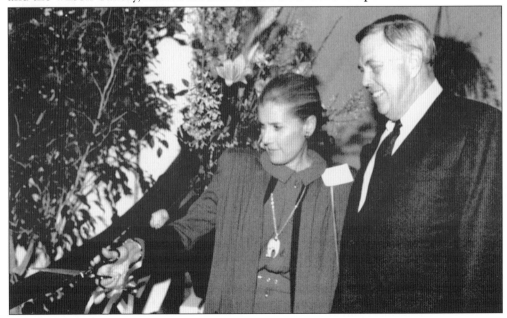

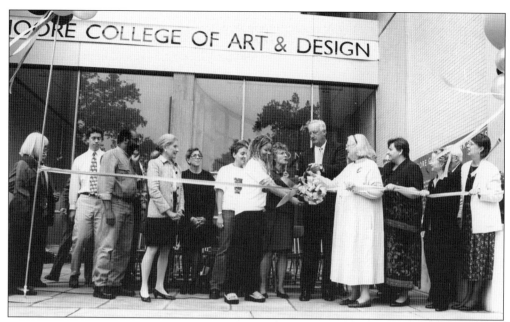

On September 12, 2000, Wilson Hall officially opened. Chair of the board of trustees Penelope P. Wilson and G. Clay von Seldeneck, chair of the board of managers, led representatives from the Moore community as they collectively cut the ceremonial ribbon. Wilson's generous investment enabled Moore to purchase and renovate Wilson Hall. The new building emphasized the community spirit of Moore by maximizing the natural light, high ceilings, and large open spaces to create a modern and intimate campus.

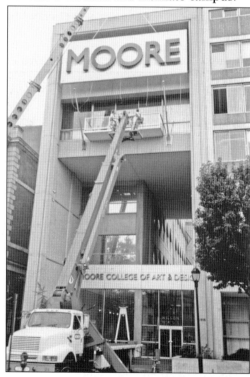

The ASTM building at 1916 Race Street was purchased by the college in 1996 and was renovated in 2000. In 2002, cranes lift the new signage for the college atop the new main entrance of the newly named Wilson Hall. The building was renovated to house administrative offices and many undergraduate classes and studios, including drawing and painting, fashion design, and a state-of-the-art technology center for computer classes.

35

The Fox Commons was built as the centerpiece of Wilson Hall. The large first-floor gathering space, with its adjoining courtyard, reflects the building's history with its classic modern aesthetic in both decor and furnishings. The space was named in honor of chair of the board of trustees Penny Fox and her husband, Robert, in recognition of their generous support.

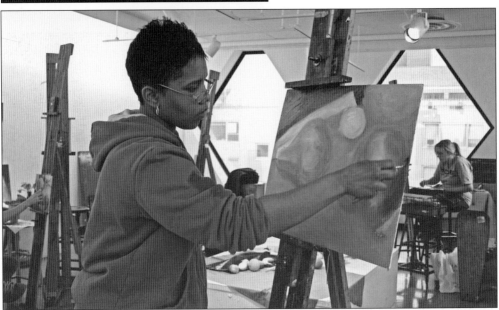

When the college expanded into Wilson Hall, it gained new bachelor of fine arts classrooms, like the painting studio pictured here with students Olu Brooks, foreground, and Megan Uhaze, background. The unusual diamond-shaped windows are fitted with shades so lighting can be controlled or direct natural light can be used. Wilson Hall also houses the executive and other administrative offices, the Great Hall, the Penny and Bob Fox Center for Digital Arts, Design, and Print Media, the McCulloch Media Center, and Fox Commons.

Three

EDUCATING WOMEN FOR CAREERS IN ART AND DESIGN

In 1930, graduates of the school are pictured drafting in the design department at La France Textile Industries. Co-ops at La France and other manufacturers provided students with practical experience, opportunities to sell their work, and future employment. Beginning in 1848, students completing designs for woodblocks, calicos, and wallpaper received 75 percent of any earned commission. The first art school to emphasize commercial design in its curriculum, the college has consistently hired faculty who are professional working artists, and internships are now required in all majors. The Art Shop at Moore, founded in 2002, sells original artwork by students and alumnae. Current graduates work in diverse fields of art and design. Students no longer intern or work at La France but at Target, L.L. Bean, and Anthropolgie. Since Harriet Sartain's day, Lenox China and Campbell's Soup have employed graduates.

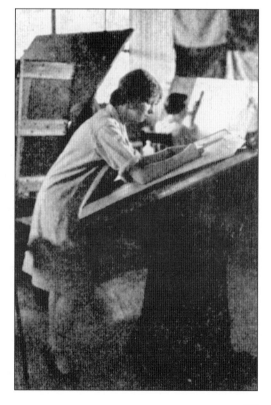

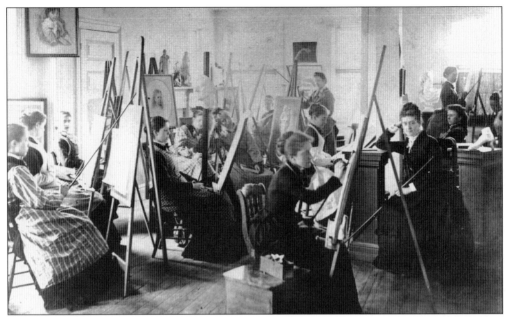

This undated photograph shows an early "preparatory class" in drawing. Identified are Elizabeth Hughes, Helen Trapier, Ada Foye, Mabel Yeager, Miss Bremer, and Kizzie McDowell. Basic tuition for five months was $100. A student's standard drawing kit at the time might include charcoals, pencils in black and in a myriad of hues, and gum erasers.

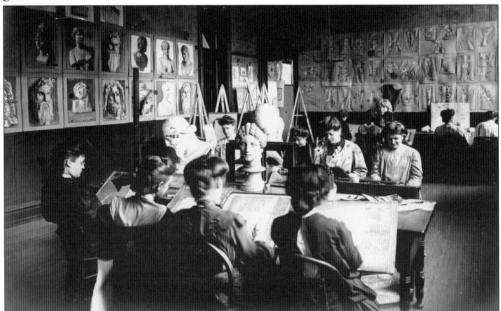

Although the plaster busts suggest that this is a portraiture class, the students pictured are actually taking a flower-drawing class. In this first-year course, students set up their blooms in small vases on the table in the center and began to capture their likenesses. Drawing from nature was one of Emily Sartain's innovations after she became principal of the school.

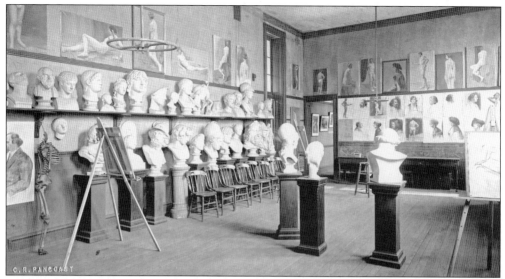

With the help of financial benefactors, the school first began to purchase casts and models from Europe in 1862. By 1870, the collection was well known and numbered more than 350. This photograph shows a large cast room that occupied space on the first floor of the building at Broad and Master Streets. Although Emily Sartain ushered in an era of drawing from life, plaster casts were useful and plentiful. When the school moved to the Benjamin Franklin Parkway, most of the casts were given to the Pennsylvania Academy of Fine Arts.

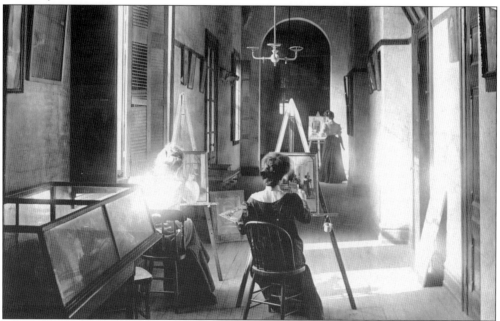

This picture from 1885 presents students working in a perspective class. A corridor in the former Forrest mansion was used not because of overcrowding in the classrooms but because it was thought to be the best place to teach the subject. The light streaming in through the windows would also present a challenge to those trying to master the art of perspective.

WILLIAM J. HORSTMANN

William J. Horstmann served consecutive terms on the board for over two decades and as board president in 1871–1872. Horstmann founded a large silk hosiery mill. Like David Brown and John Sartain, he hired students of the school. In 1825, William J. Horstmann's father, William H. Horstmann, introduced the first Jacquard loom into the United States from Germany. William J. Horstmann also continued to work in the family business, which made a fortune during the Civil War supplying military uniforms, regalia, and swords.

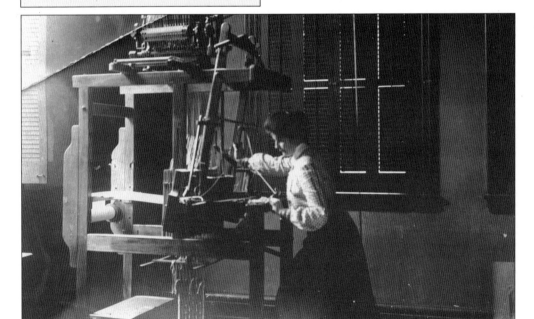

Edna Speakman is shown at a dobby loom—a type of Jacquard loom—around 1902. Such looms proved essential for the school in the second decade of the 20th century. Handloom production outweighed power loom production as late as the 1870s in the Philadelphia area. Power looms were expensive, and manufacturers had great difficulty matching the quality of goods produced with handlooms. Students trained to work on the Jacquard loom had an advantage when seeking employment.

China painting was a popular class in the late 1880s, in part because of the burgeoning arts and crafts movement fueled by the demand for goods in a prosperous post–Civil War America. Rookwood and Newcomb pottery, like other decorative arts companies, exhibited their finery at the Philadelphia centennial. Identified students in this school photograph include Annie Greene, Helen Collins, and Sophie Dutton.

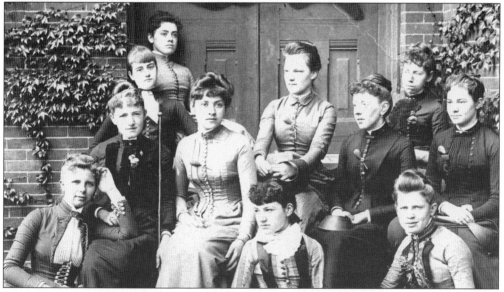

A wood-engraving class poses in 1894 in the courtyard at Broad and Master Streets. Their lesson has been interrupted by the call to be photographed; note the tools tucked between the buttons on the front of their dresses and the visors that rest in some laps. The ivy that festooned the courtyard became a symbol for the school, appearing on medals, letterhead, and commemorative gifts in subsequent years, although it is no longer used today as a symbol for Moore.

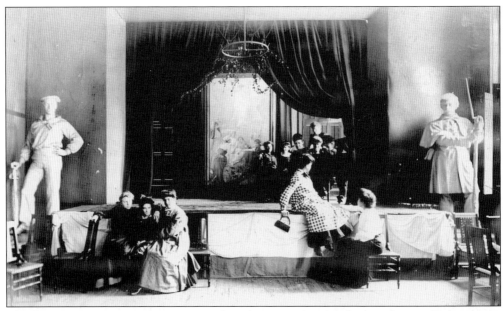

The former Forrest mansion at Broad and Master Streets featured a small theater in the basement. Dated 1897, this photograph shows the Fashion Design Department using the stage to exhibit student work. Shakespearean actor Edwin Forrest had built the small stage in the basement to rehearse his plays. The area was later used to stage puppet shows.

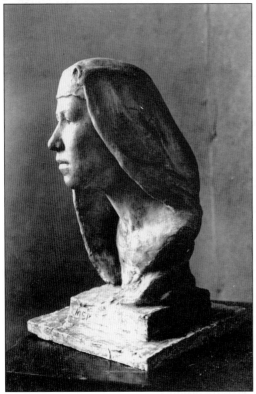

In 1853, at the time the school was incorporated, the curriculum included three departments: drawing, industrial arts, and wood engraving. After the Civil War, two new areas were added: fine arts and a "normal art" course of study for art teachers. Emily Sartain brought noted sculptor Samuel Murray to the school in 1892. This student work from 1893 no doubt reflects Samuel Murray's teaching.

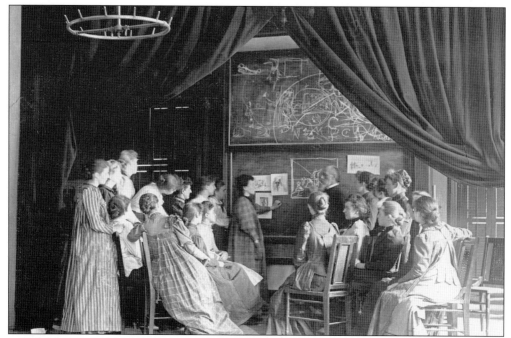

In what is probably a scene of critique, students gather around a blackboard on the stage at the Broad and Master Streets location in 1901. Smocks were worn over dresses while in the building: it was considered inappropriate to be seen outside in a smock. A gaslight fixture hangs just in front of the stage.

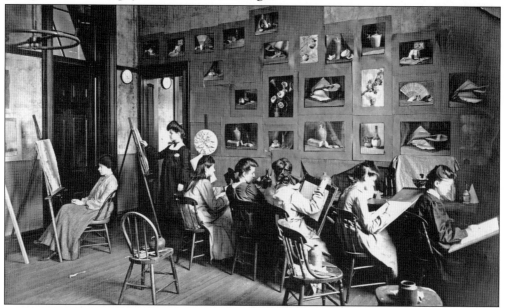

In this undated photograph, a group of still life students work from tableaux on the third floor of the Philadelphia School of Design for Women at the Broad and Master Streets location. The school's 1871 catalog advertised an extensive collection of studies from the "flat" numbering "about 6,000 copies, embracing every description of Drawing Examples used in the European School of Art and Design."

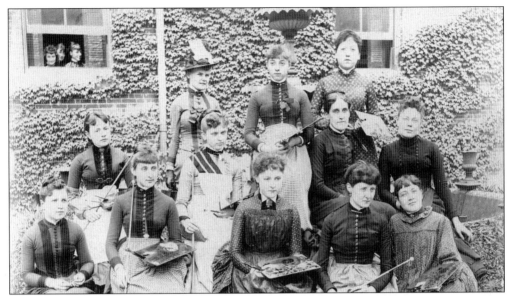

This photograph, dated 1882, depicts Sara Pennypacker's painting class posing with palettes and maulsticks in the courtyard at the school's Broad and Master Streets location. Maulsticks were used to steady the hand while applying paint to the canvas. Typically a rag would be wrapped around the end of the stick that rested against the painting so that the surface would not be marked. Note the faces in the window in the upper right-hand corner.

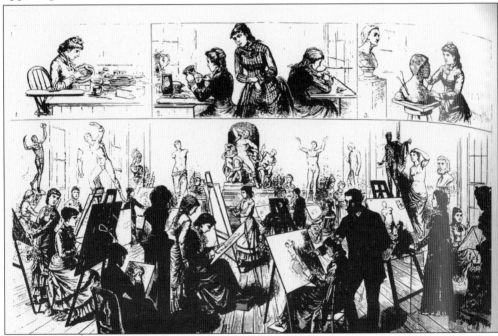

This illustration by Walter Goater appeared in the January 15, 1881, issue of *Frank Leslie's Illustrated Newspaper*. It shows students at the Philadelphia School of Design for Women attending classes, including, from top left to right, decorating china, painting pottery, sculpting, and drawing from casts and models.

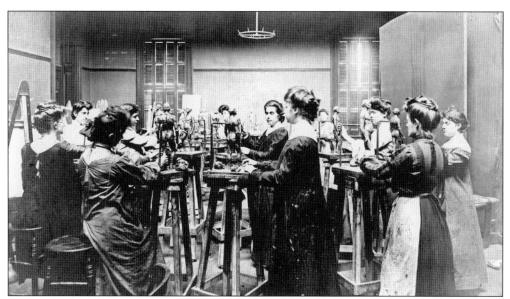

In this photograph dated 1901–1903, students sculpt from a live male model (not shown) in a modeling from life class. Minnie Miller was the instructor at this time. Male models did not pose completely naked. A small cloth or G-string would have covered the model's genitalia for many more years. In 1890, alumna and instructor Alice Barber Stephens, a working illustrator, successfully petitioned Emily Sartain to offer classes using live male models—a privilege not offered women at other institutions.

This prospectus from the 1901–1902 school year shows the curriculum offered at the time. Catalogs from the school, the first in the country to emphasize commercial art, give insight into the history of decorative arts in the United States. Note the offering of stained glass. Louis C. Tiffany incorporated Tiffany Glass Company in 1885, and women played an important role in the history of the company. Textile designer Candace Wheeler had been a partner in an earlier glassworks venture with Tiffany. In 1892, Tiffany Studios formed the Women's Glass Cutting Department, hiring young women from art schools.

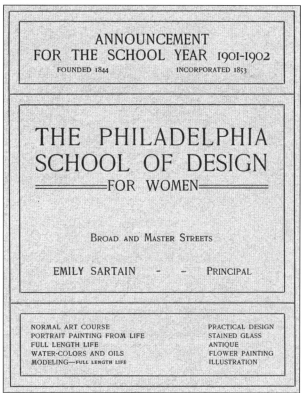

ANNOUNCEMENT
FOR THE SCHOOL YEAR 1901-1902
FOUNDED 1844 INCORPORATED 1853

THE PHILADELPHIA
SCHOOL OF DESIGN
========FOR WOMEN========

BROAD AND MASTER STREETS

EMILY SARTAIN - - PRINCIPAL

NORMAL ART COURSE
PORTRAIT PAINTING FROM LIFE
FULL LENGTH LIFE
WATER-COLORS AND OILS
MODELING—FULL LENGTH LIFE

PRACTICAL DESIGN
STAINED GLASS
ANTIQUE
FLOWER PAINTING
ILLUSTRATION

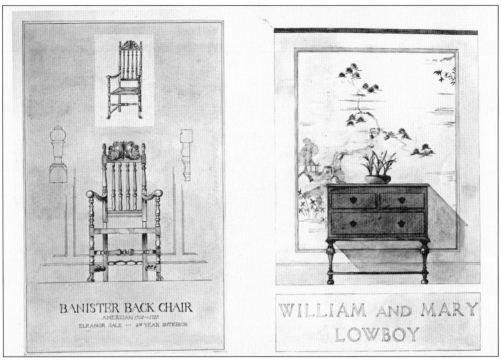

BANISTER BACK CHAIR
AMERICAN 1700~1725
ELEANOR SALE — 3ᴿᴰ YEAR INTERIOR

WILLIAM AND MARY
LOWBOY

These two designs for furniture were drawn by Eleanor Sale '28 in her third-year interior design class. She later became a faculty member in interior design, a post she held for many years. Interior design was first introduced to the curriculum in 1919. The college will launch a master of fine arts program in interior design in 2009.

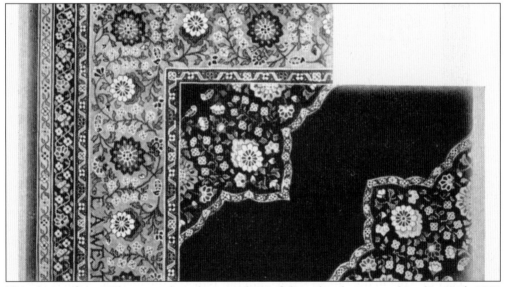

This design for a Wilton rug done by a student of the school appeared in the 1914–1915 catalog. The catalog advertises "the systematic instruction in practical designing as applied to manufacturers." It also mentions a library of unusual value, including a large collection of prints and art books bequeathed by John Sartain, who was fond of Oriental art. The student of this rug design referenced Indian influences for her design.

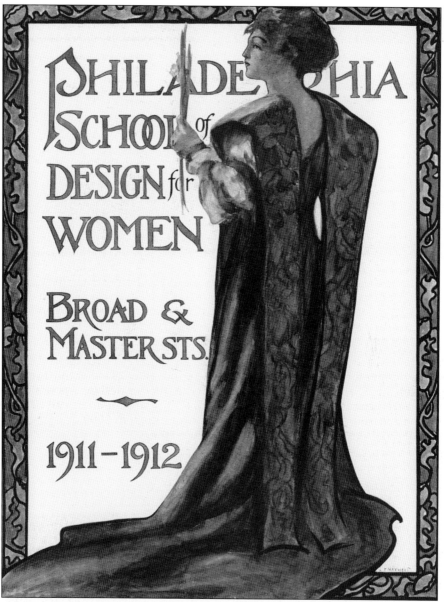

PHILADELPHIA
SCHOOL of
DESIGN for
WOMEN

BROAD &
MASTER STS.

1911-1912

As far back as 1871, the school published a catalog once a year listing courses offered and the fee schedule. Until 1911, the cover was plain text. The catalog shown here is the first to feature a figurative design. By the dawn of the 19th century, posters had become a fashionable way to advertise, and this may have influenced the decision to produce a more appealing cover. Students sometimes competed to create the cover design. This figure also graced the cover of the 1913–1914 catalog in a different color palette. The depiction of the woman shows a strong figure commanding the frame. While women did not get the vote in the United States until the 19th Amendment was ratified in 1920, the women's suffrage movement was active when this cover was designed. As a result, women's fashions were becoming more flexible and less fitting at the waist as the corset was modified. The ornamental border also reflects some of the arts and crafts movement popularized in England by William Morris.

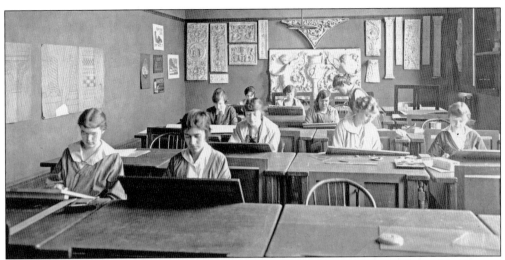

This photograph shows a 1922 interior design class in ornamental drawing. Harriet Sartain emphasized that education in the arts should be practical so that graduates of the school could find employment in manufacturing firms. The classical Greek frieze in the rear of the classroom was meant to inspire an atmosphere of creativity and reminded students that they were part of a long and honored tradition in the plastic arts.

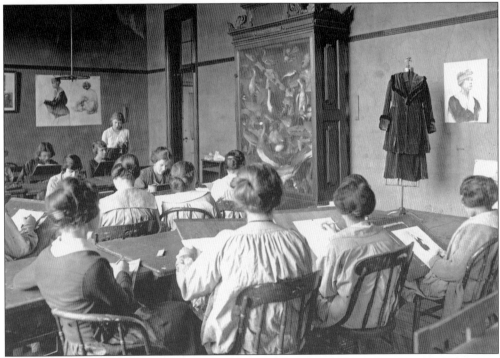

Probably dated 1917, this photograph shows students sketching the dress on the right for "costume class." Lucille Howard taught fashion illustration for more than 45 years at the school. The large case in the center contained an assortment of stuffed birds, a gift from a donor, that were used for sketching purposes. Before widespread use of photography in magazines, fashion illustration was the primary means for the reading public to discover the latest fashions.

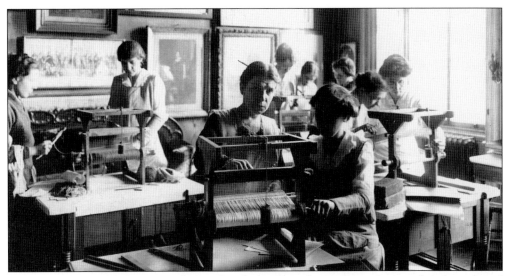

A class works at table looms in this undated photograph. Students designed and produced their own textile products. A common practice was for one student to start a project and for a second student to finish the piece. Textile design at the school was an essential class because Philadelphia firms continued to be among the world leaders in the manufacture of mass-market textiles.

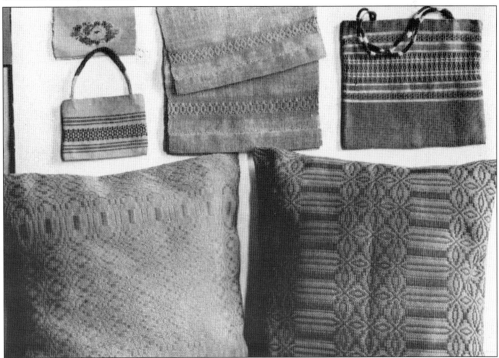

These samples of work done by students of the normal arts course appeared in the 1916 school catalog. The work shows traditional weaving patterns produced on a harness loom. Today's textile design students still learn hand-weaving techniques using harness looms. The normal arts, or teacher's education, curriculum was introduced after the Civil War when the school expanded courses beyond the industrial arts.

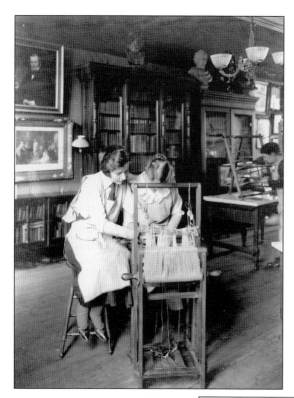

This 1917 scene from an occupational therapy weaving class shows John Sartain's furnishings. Responding to dwindling enrollment during World War I, the school established the Philadelphia School of Occupational Therapy in 1918, the first of its kind in the United States. (The University of Pennsylvania's School of Nursing took over the School of Occupational Therapy in 1920.) During World War I, students and graduates designed war posters, camouflage clothing, and naval destroyers and were employed as draftsmen by the U.S. Army.

This drawing by student Gladys Smith, used for the catalog cover in 1916–1917 and 1917–1918, depicts a woman in a Greek toga reclining on an artist's palette. While the date founded is listed here as 1844, the school was founded in 1848. The earlier date may refer to Sarah Peter's involvement with the Magdalen Society. The design reflects the fashion for art nouveau.

PHILADELPHIA · SCHOOL · OF · DESIGN

1917 1918

FOR · WOMEN

FOUNDED 1844
INCORPORATED 1853

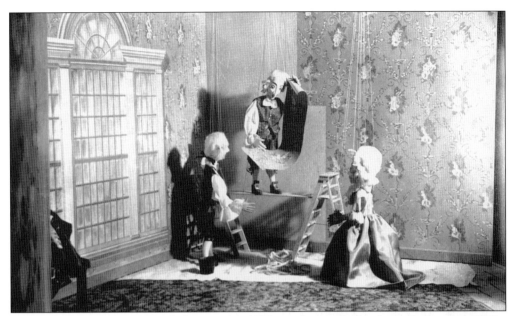

Puppetry became a required class in the 1920s and was taught through the mid-1950s. Students designed the figures, costumes, and sets. They also adapted stories and put on performances. Louise Zimmerman Stahl '42 remembers the classes fondly as a welcome relief from the rigors of other coursework. Puppets are shown here in a drawing room; one puppet is applying wallpaper while his two companions encourage him.

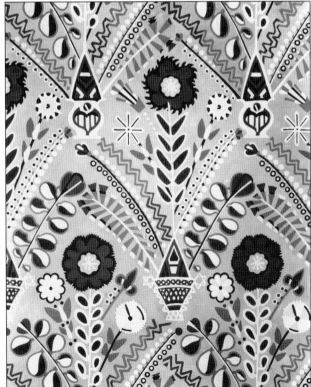

This is a design on fabric from 1930. The pattern, called "Tapestry," was created by M. A. Griffin. After 1920, the great majority of students at the school chose practical commercial courses of study. Seventy percent of students in 1922 were enrolled in textile design, general illustration, interior decoration (the term interior design comes into use at the school in the 1940s), advertising, and fashion courses.

Illustration encompassed the design and production of wallpaper as well as more traditional illustration. This playful wallpaper design, intended for a nursery or child's room, was made in 1925 by an unidentified student. Commercial education in the arts prepared students to become designers in many of the manufacturing firms in Philadelphia.

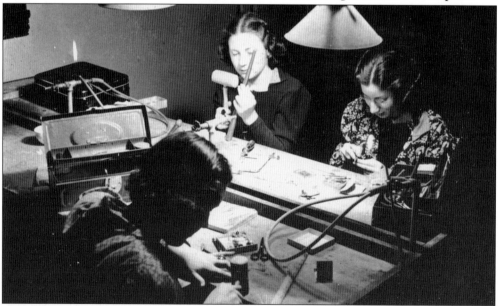

Students work on jewelry in this undated photograph from Miriam Cone's class. The woman in the center is shaping a ring by sliding it onto a mandril and tapping it with a mallet. During the working of the metals, the flame in the upper-left corner was directed by blowing into the rubber tubing. Today majors in three-dimensional fine art may focus on ceramics, metals, jewelry, sculpture, cross-disciplinary study.

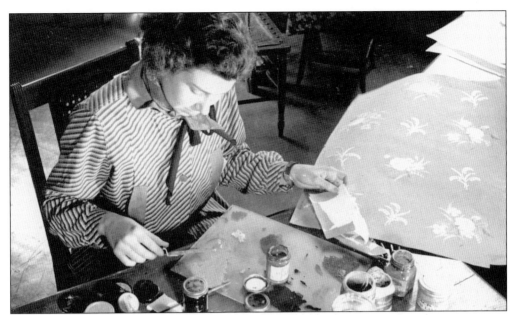

Here a student in Edna Leonhardt's textile design class, probably from the 1930s, works on a textile croquis (sketch). Leonhardt (class of 1923) was one of a number of talented alumnae who later taught at the school. Harriet Sartain (class of 1892), Alice Barber Stephens (class of 1875), Charlotte Harding (class of 1892), Louise Zimmerman Stahl (class of 1942), Lynne Jordan Horoschak (class of 1966), Deborah Warner (class of 1969), Deborah Larkin (class of 1970), and Mary Judge (class of 1975) are other notable examples.

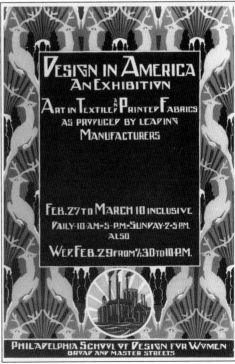

In 1932, this poster was designed by a student of the school to advertise the Design in America exhibition. The exhibition, which began in the 1920s, became an annual affair that displayed products designed by graduates of the school for local manufacturers such as La France, Lenox China, and the Quaker Lace Company. (Hagley Museum and Library.)

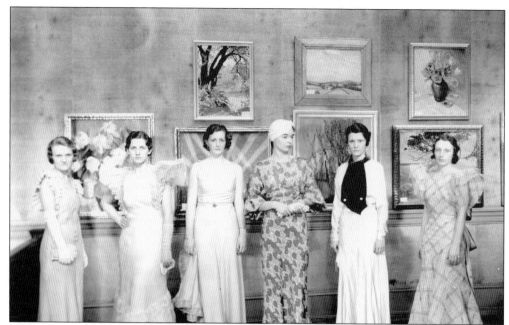

The school offered evening classes in addition to its regular curriculum. In a class taught by Marguerite Wickersham in 1932, six students model the gowns they designed and constructed. The school continued to be sensitive to trends in the arts and the desire for classes. As demand for classes like china painting fell, classes such as interior design and ceramics took its place.

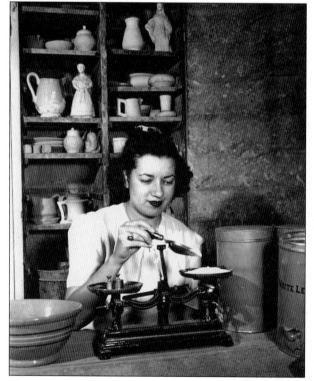

Students in Ida Fennimore's ceramics class had to mix their own glazes using a gram scale. The kilns were in the basement at the Broad and Master Streets location. Ruth Green is shown here in the preliminary stage of preparing her glaze. She was a student in teacher certification, a popular program that Moore continues today.

Instructor Samuel Murray is shown critiquing Madeline Robertson's work in modeling class in 1937. Murray joined the faculty the same year as painter Robert Henri but stayed considerably longer: 48 years. Murray was an accomplished sculptor whose works are in the Metropolitan Museum of Art and St. Patrick's Cathedral in New York City. His statue of Commodore John Barry is in Independence Square. He always wore a bow tie.

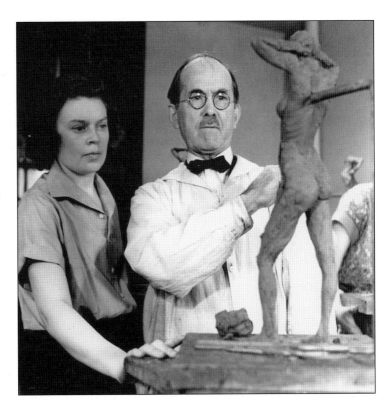

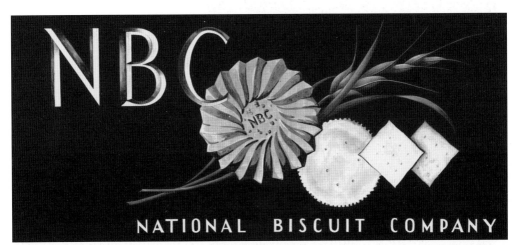

An example of an assignment from a 1940 graphic design class, this work by Louise Zimmerman Stahl '42 was used by National Biscuit Company as an advertisement. The advertisement ran on trolleys throughout the city. Stahl became a beloved faculty member, teaching generations of students color theory. In 2006, alumnae raised money to renovate the main residence hall, renaming it Louise Zimmerman Stahl Residence Hall in her honor.

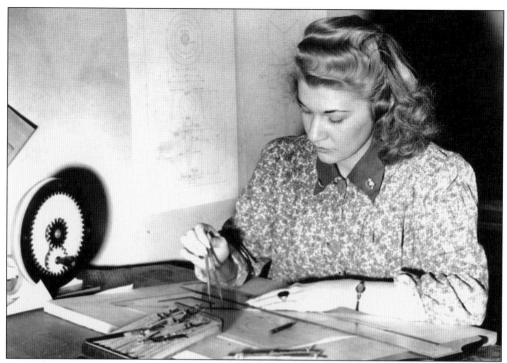

Student Glenna Sundermann is shown here in the 1940s using precision instruments in the first-year basic course. The use of such instruments was one phase of the Elements of Perspective class.

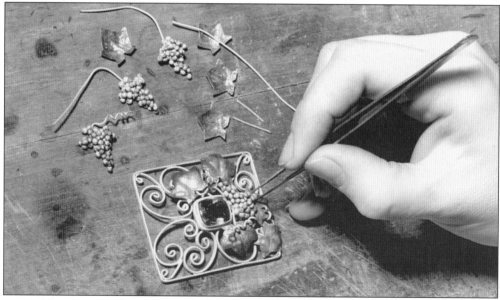

Eva Dahl is shown here making a brooch of sterling silver and amethyst in Miriam Cone's class. Taken in 1940, the photograph shows the intricate detail and precise placement of elements necessary for fine jewelry making. Dahl's steady hand places bunches of grapes and leaves on a scroll background. Harriet Sartain's belief that the school should offer training in design beyond textiles finds its expression in this picture.

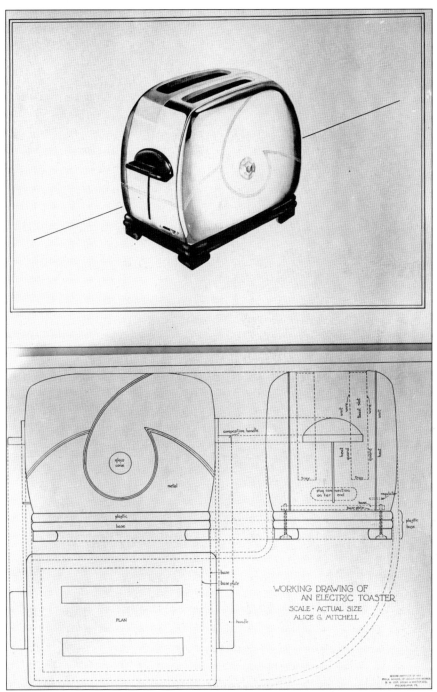

WORKING DRAWING OF
AN ELECTRIC TOASTER
SCALE · ACTUAL SIZE
ALICE G. MITCHELL

Alice Mitchell produced this working drawing of the inside and outside of an electric toaster for technical design. The idea behind such an assignment was to encourage students to design a product and then break it down for production. Jacob Riegel was the instructor in 1941 when this drawing was made. The exercise helped develop a student's basic analytical, drafting, and problem-solving skills essential in the applied design arts.

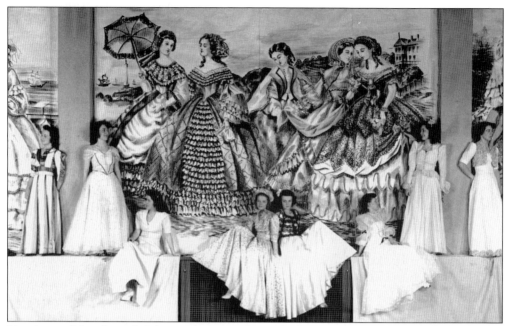

Members of the class of 1942 are shown at the end-of-the-year fashion show in 1940. Anne Mehulik and Maria Harland are pictured in the center. Millie Ivins's fashion illustration class designed and executed the murals on paper. In the 1920s and 1930s, students and faculty painted murals not unlike those shown here, transforming whole rooms into exotic locations for elaborate costume balls.

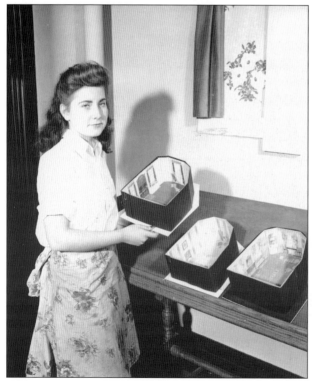

Interior design combined furniture design, textile design, and industrial design. A student, such as the one shown here with interior room models, would create everything from carpets and curtains to furniture and lighting fixtures for her miniature room. Moore's emphasis on design that finds a home in the industrial marketplace at this time is in keeping with the aims of founder Sarah Peter.

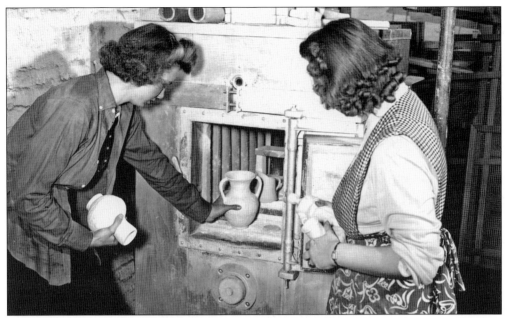

The kilns at the Broad and Master Streets location were in the basement. Ceramics was a required class for all students in 1940 when this photograph was taken. Ida Fennimore was the teacher. Students built and fired their own pieces and mixed glazes using a gram scale.

Alfred DiLardi strikes a pose with his photography class. As photography has changed, so has Moore. Photography classes were offered with the ponderous equipment of the early 20th century. Although the students here are pictured with a modern camera of the time, Moore now offers a photography and digital arts major.

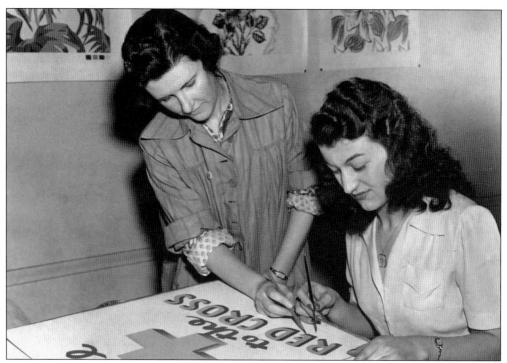

Graphic design instructor Margaret Wadsworth gives pointers to Elsie Breda on her poster "Give to the Red Cross" in the 1950s. In addition to public service advertisements, students in graphic design classes in this era also produced commercial advertisements for items such as soap and shoes and events such as the Philadelphia Flower Show and the Olympics. Another Olympic link to the school is distinguished alumna Holly Straley Hatton '70, an advertising major at Moore and two-time Olympic crew team coach.

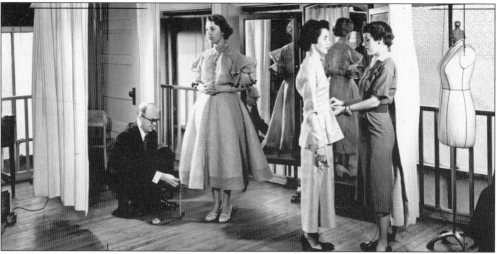

Here is an interior dressing room at Broad and Master Streets. Albert Gordon and Madeline Moore (far right) help student models to get ready for the stage in the 1950s. The school has exhibited a sustained commitment to fashion design throughout its 160 years. Although the styles have evolved and changed over time, fashion design and its attendant shows have continued to be a hallmark event at the college.

Sara Jane Carlito, left, was a recent graduate of Moore Institute when she won first prize in an international contest sponsored by a Philadelphia textile firm in 1952. She is holding the drawing that garnered her the prize. Also pictured are Natalie Yulsman, honorable mention, and Ann Fairchild, second-prize winner. The school has a long-standing tradition of competitions and prizes sponsored by manufacturers.

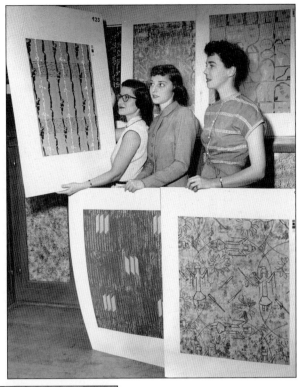

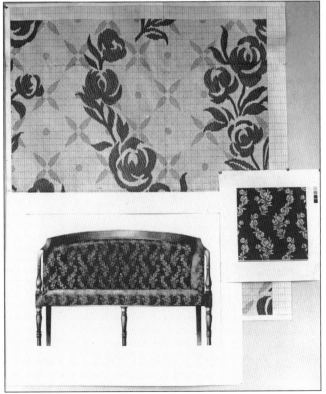

This display shows work by an unnamed student of Edna Leonhardt's jacquard textile design class from the 1960s. The work exhibits the process from croquis (sketch) to sample fabric swatch and its application to upholster a settee. The student may have been either a textile design or interior design major because the Interior Design Department encouraged courses in decorative techniques. Students today, in much the same way, may choose a double major in textile and fashion design, interior design, or art history.

61

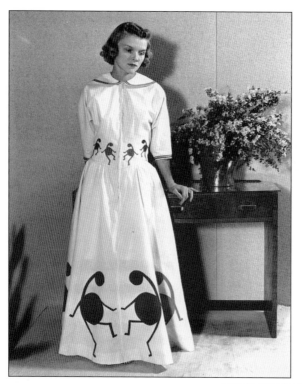

This is a lively dress from the 1940s, decorated with anthropomorphic figures. Fashion design at Moore has reflected the changing tastes of the time. From the unconstructed dresses of the 1920s to the wide-shouldered look of the 1980s and beyond, Moore students have kept pace with fashion's quickly changing landscape. Initially, students created only fashions for women, but students have been designing clothes for men and children at least since the 1950s.

This fashion illustration was done by student Joan Marie Sibley in 1962. Fashion in the 1960s broke many traditions and saw the introduction of the miniskirt. This illustration and other examples of student work representing a variety of disciplines taught at the school now hang in the board room of the college. Post–World War II consumer demand created new jobs in advertising, interior design, and the fashion industry.

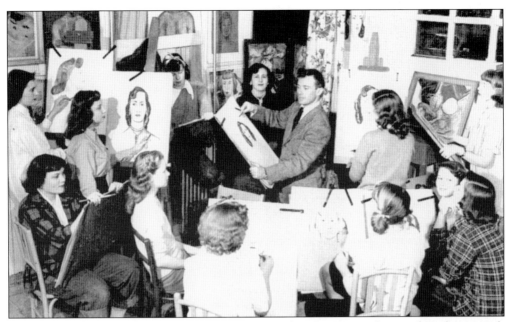

Painting professor and chair Doyla Goutman teaches a portrait class in this photograph from the 1950s. Goutman lived and worked as an art director at Paramount Studios in Hollywood before pursuing art degrees in Chicago and Philadelphia. Goutman taught at the school for 33 years and was known for his passion and humor, as well as his stories of nights palling around with Charlie Chaplin and portrait sittings with Bing Crosby, Paulette Goddard, Cary Grant, and Clark Gable.

This image from the 1963 yearbook identifies faculty pictured here as follows: Victor Carlson, Alden Wicks, Ranulph Bye, Walter Redding, Jack Hoffman, Jane Swan, John Hanlen, George Sklar, Elizabeth Lovett Stewart, Constance Rosenthal, Charles Barton, Angela Centrella, John Curl, Elizabeth Freitag, Jack Porter, Joseph Seidle, Georgia Woeber, Paul Shaub, Edward Rosanio, Patricia T. Slepian, John Reid, Elizabeth Emily Reinsel, Elsie Knaus, Jessie Wissler, Edna Leonhardt Acker, and Jean Halvorsen Green.

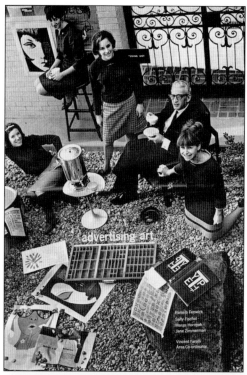

The Advertising Art Department pictured here in the 1966 yearbook includes students Pamela Fenwick, Sally Fischel, Marge Hornyak, and Jane Zimmerman Walentas and professor Vincent Faralli. Moore in 1965 was a changing institution. Around the time of this photograph, Moore embarked on a campaign to publicize itself with a series of 10 television programs shown in major cities across the country. Hosted by Dr. Mayo Bryce, president of the college, the programs showcased the professionalism of the students and faculty.

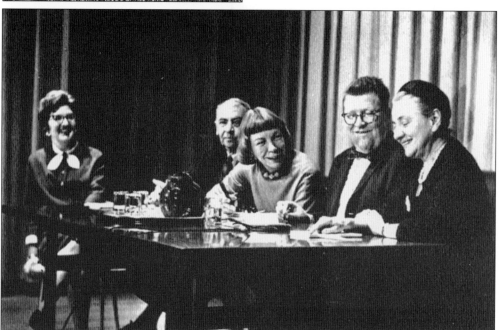

Fine arts faculty and visiting faculty participated in this Fine Arts Debate in 1963. College professor Louise Zimmerman Stahl '42 is shown at the far left and appears with fine arts faculty and guests, from left to right, Edward Shenton, Edna Andrade, Alden Wicks, and Beatrice Fenton in the school auditorium. The auditorium was later named for Mary Grace Stewart, who taught at the school for over 30 years.

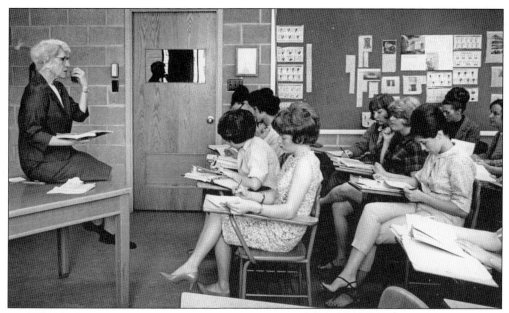

Mary Grace Stewart teaches English in the General Studies Department in this photograph from 1965. Stewart is well known for modernizing the general studies curriculum. She was also instrumental in bringing writers, musicians, and performers to campus to share their artistic creations with appreciative Moore students. The 350-seat Stewart Auditorium on campus is named in her honor.

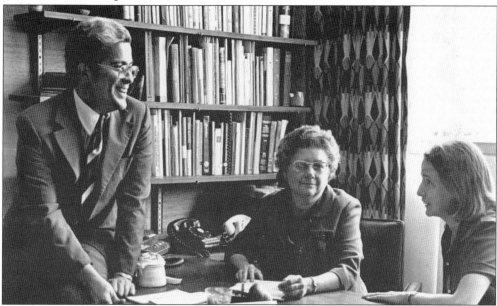

While art history courses were offered at the school from the beginning, the art history major was not introduced until 1973. In this photograph, Dr. Eugene Kist, the program's chief organizer, discusses the program with Dean Hilda K. Schoenwetter (center) and Dr. Beverly Almgren, cochair of the Department of the Humanities, Social Sciences and Art History. Today the college offers a bachelor of fine arts in art history through the Liberal Arts Department.

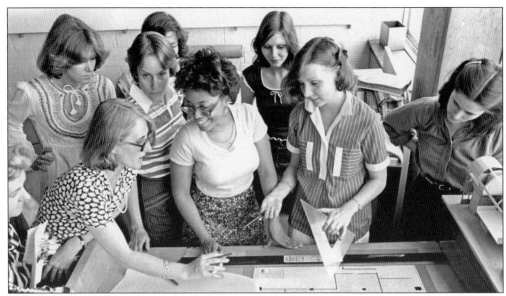

Moore became the first school in the country to offer education in interior design that fully met the requirements established by the American Institute of Decorators in 1938. This photograph of students in Harriet Roberts's interior design class was taken 50 years later in 1978. At that time, technology was beginning to profoundly affect interior design and other design fields. The college established a computer-aided design and drafting (CADD) laboratory in 1990.

Eileen Rudisill Miller created this charcoal drawing in 1977. She was a fashion illustration major and painting minor who went on to work for the Franklin Mint. A deep immersion in the fundamentals of drawing and design has been Moore's aim since the school began. The success of generations of Moore women stands on the shoulders of the rigorous basics classes.

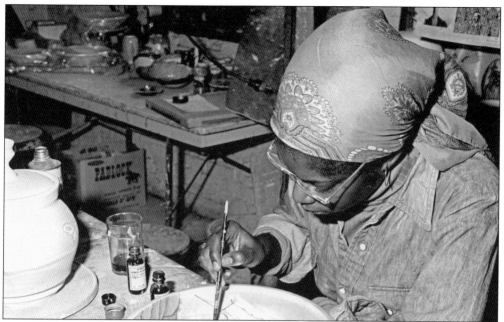

Student Shirley Johnson is shown painting on ceramic in this photograph dated 1974. Although school policies and the prevailing social atmosphere made racial diversity difficult in the early years, the school did enroll students from a variety of social and religious backgrounds from its founding—one of the few to do so. Moore continues to attract a diverse student body.

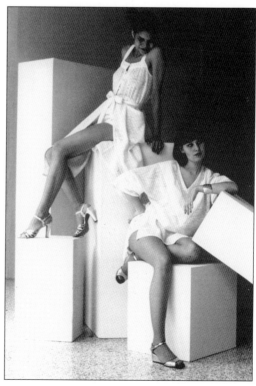

This photograph of student fashions was used to promote the 1979 spring fashion show. Fashion design sophomores, juniors, and seniors show their designs, with seniors presenting a senior collection. Much like the alliance of art and industry in earlier days, the popular annual event is sponsored by fashion houses, manufacturers, and other businesses, with prizes given by professional critics and judges. The annual fashion show was first held in the auditorium of Wanamaker's department store.

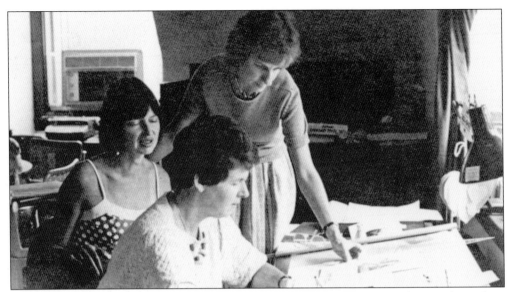

One of the college's strengths has been that faculty are practicing professionals in their fields. Advertising design alumna and faculty member Joanne (Santa Maria) Dhody '68 is an example. She is shown here in the foreground in 1985, the year she joined the faculty. Another alumna faculty member, Jonel Becker Sofian '68, standing, discusses a project with student Joan Menocal. Dhody began teaching after an award-winning career as a graphic designer and continued to freelance while teaching.

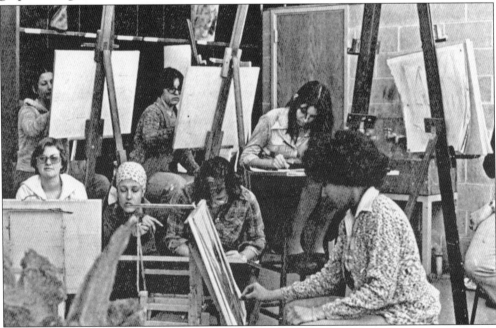

Lagging enrollment in the 1970s led the trustees to raise the possibility of coeducation. By the 1980s when this photograph was taken, the school's enrollment was strong again, and the fine arts classrooms in Sarah Peter Hall were overcrowded. The campus expansion in 2000 doubled Moore's classroom and studio spaces and created larger classrooms for painting and drawing.

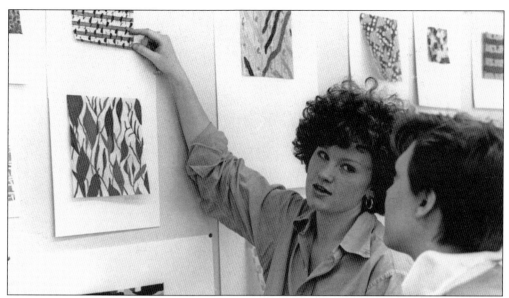

This photograph, taken in the 1980s, shows Gina McGuire '82 discussing a textile design assignment with another student. McGuire worked as a designer for Neiman Marcus after graduation. Moore's emphasis on education for careers in design and industry was novel in the 1840s. When the school began, it was the first art school to emphasize commercial design in its curriculum. The legacy of Sarah Peter continues to be the cornerstone of Moore's mission.

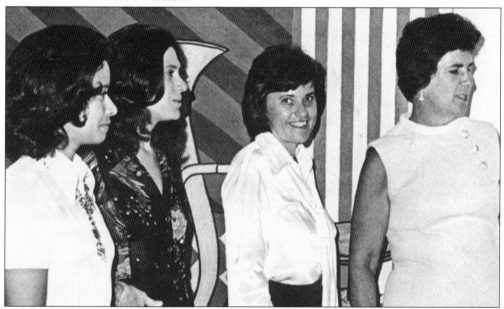

Pictured in 1974 are Dolores Lewis, registrar and head of the college's Continuing Education Program, with three of the department's former students: Assistant Dean Mildred K. Keil, Gloria Barbre, and Frances Metzman. The college's Continuing Education Department was formally founded in 1967, although night and evening classes for women and art classes for children were offered as early as the 1920s. Today Continuing Education serves 300 men and women and 1,200 boys and girls annually.

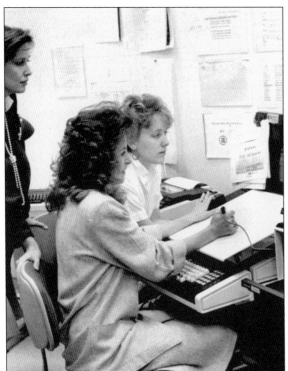

This 1986 photograph shows then-graphic-design majors Sue Woodall '87 and Tammy Daciuk '87 at work at Genigraphics Corporation in Philadelphia as part of their summer co-op experience. During that time, the women worked with two Moore alumnae: Genigraphics art director Alma York '84 and console artist Tina Ramsik '85. Here Woodall watches as Daciuk creates slides and York (standing) looks on.

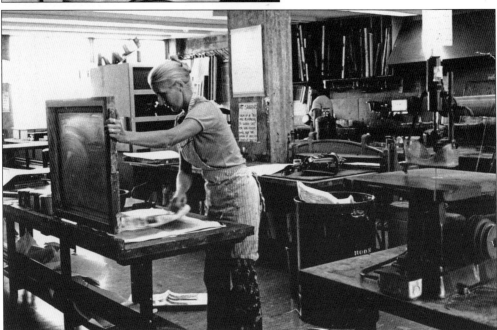

This photograph of a student in the printmaking studio at the college appeared in the 1974 catalog issue of the *Moore College of Art Bulletin*. At the time this photograph was taken, Leonard Nelson was chair of the Printmaking Department. Nelson studied at both the Pennsylvania Academy of the Fine Arts and the Barnes Foundation and taught at Moore for 29 years.

Pictured is an eveningwear design from the Stealing Beauty collection by Jia Lin '03 from the 2003 annual fashion show held that year on May 18 at Philadelphia's Wyndham Franklin Plaza Hotel. Each year, the much-anticipated fashion extravaganza features collections by senior, junior, and sophomore students from Moore College of Art & Design. Lead sponsors today include David's Bridal and Charming Shoppes, Inc., and the event features original pieces, including casual and eveningwear collections, from from students.

Around 1858, the school became the first in the country to offer courses in teaching art, later adopting normal art, or teacher education, into the curriculum. In 1931, the Commonwealth of Pennsylvania authorized the school to grant the bachelor of science in art education. Here art education students judge the work of artists from kindergarten through 12th grade for the 2007 Youth Art Awards. In 2008, the Middle States Commission on Higher Education approved a new master of art in art education with an emphasis in special needs and two other graduate programs to be launched by the college in the summer of 2009.

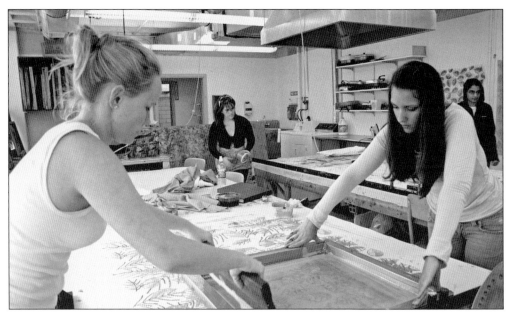

Digital textile printing and other computer-aided textile design is taught today, in addition to techniques practiced by the school during its early days. Students in this 2007 textile screen-printing class use a technique first introduced at the college in the 1940s. The design is applied to cloth one color at a time by pressing ink through a screen on which the design has been applied, usually via a photographic process.

Increasingly, technology plays a part in all design fields, as well as in the fine arts. In 2006, the campus went wireless and a laptop initiative was introduced, requiring students enrolling in the bachelor of fine arts degree program to purchase a laptop computer. Here fashion design seniors, from left to right, Asma Iqbal, Shavonne Cooper, and Colleen Sweeney review fashion croquis (sketches) in preparation for the 2007 fashion show.

Four

MAKING THEIR MARK

Emmy Award–winning costume designer Polly Smith graduated from Moore College of Art in 1971. Smith, cocreator of the Jogbra, spent almost 25 years designing for Jim Henson's Muppets. Like Smith, many of the school's administrators, graduates, and faculty have made their mark in the visual arts. Chapter 1 introduced notable administrators such as Thomas Braidwood and the Sartains. Acclaimed alumnae include illustrator Jessie Willcox Smith, painter Alice Neel, and fashion designer Adrienne Vittadini. Other alumnae, including Esther Richards, the first woman to design a U.S. postage stamp, while less widely known, broke career barriers and share an entrepreneurial spirit with the students of today. Faculty members such as Robert Henri helped build the school's national reputation and continue to inspire new generations of Moore artists and designers.

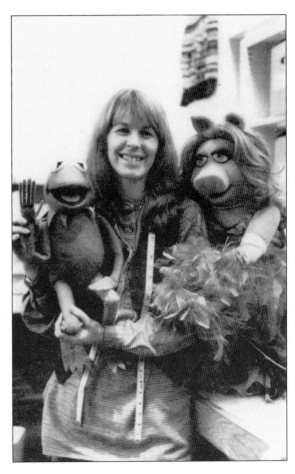

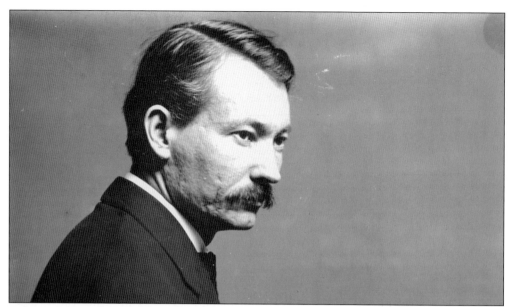

Emily Sartain hired painter Robert Henri to teach drawing and composition in 1892. Henri earned $520 a year. While teaching at the school, he rented a studio at 806 Walnut Street, sharing the space with newspaper illustrators John Sloan and William Glackens. Henri's paintings may well have been influenced by their coverage of the city's news. Henri became a leader of the Ashcan school, which captured unglamorous portraits of real urban life. He posed for this photograph by Gertrude Kasebier in New York City in 1900. (Library of Congress, Prints and Photographs Division.)

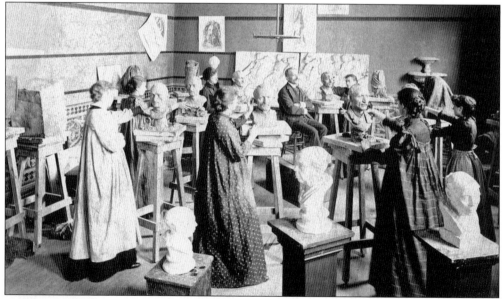

Successful illustrator Charlotte Harding (1873–1959) attended the school on scholarship in 1889. Harding helped to support her family with work she did for *Collier's*, *Harper's*, and other magazines. Like many female illustrators in Philadelphia, Harding was an active member of the Plastic Club. She also returned to the school as an instructor. She is identified as one of the students in this photograph of Samuel Murray's sculpture class.

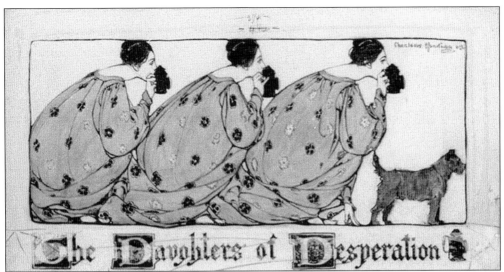

This charcoal and wash drawing, *The Daughters of Desperation* by Charlotte Harding, class of 1892, was published in 1903. The drawing illustrated an article of the same name by Hildegarde Brocke and appeared in *Collier's* weekly in 1904. She exhibited at the St. Louis world's fair in 1904, the Art Institute of Chicago, and the Panama Pacific Exhibition of 1915. Harding, Alice Barber Stephens, class of 1875, and the Red Rose Girls all worked during what is considered the golden age of illustration. (Library of Congress, Prints and Photographs Division.)

This 1904 illustration by alumna Elizabeth Shippen Green depicts Green and fellow alumna Jessie Willcox Smith, Violet Oakley, and friends outside the Red Rose Inn, Villanova, where the three shared a home and studio. Their 17-year association earned them the name the Red Rose Girls from Howard Pyle, one of their former teachers. Green and Smith studied at the school and later at the Pennsylvania Academy of the Fine Arts where they met Oakley. (Library of Congress, Prints and Photographs Division.)

Harper's published Elizabeth Shippen Green's watercolor and charcoal drawing entitled *Giséle* in 1908 as an illustration to "The Dream" by Justus Miles Forman. Shippen Green's art nouveau paintings often graced the covers of popular magazines such as *Collier's* and *Harper's*. At the time, illustrators enjoyed a status like that of celebrities. Jessie Willcox Smith's illustrations of a *Child's Garden of Verses* remain well known. (Library of Congress, Prints and Photographs Division.)

This drawing by Alice Barber Stephens, class of 1875, published by *Harper's* in 1909, illustrates Olicia Howard Dunbar's "The Solvent." Barber, who also studied with Thomas Eakins at the Pennsylvania Academy of the Fine Arts, began selling illustrations soon after she enrolled at the Philadelphia School of Design for Women in 1870. She taught at the school from 1887 to 1904 and in 1890 successfully petitioned to offer the first figure class to use live nude models—until 1920, male models wore loincloths. (Library of Congress, Prints and Photographs Division.)

This photograph of Jessie Willcox Smith was taken in 1917. One of the most successful illustrators of her day, Smith illustrated more than 40 children's books, including Charles Kingsley's *The Water-Babies* (1916). Smith enrolled at the Philadelphia School of Design for Women in 1884 at age 16. She went on to study at the Pennsylvania Academy of the Fine Arts and later with Howard Pyle. (Library of Congress, Prints and Photographs Division.)

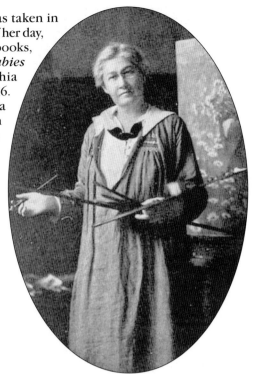

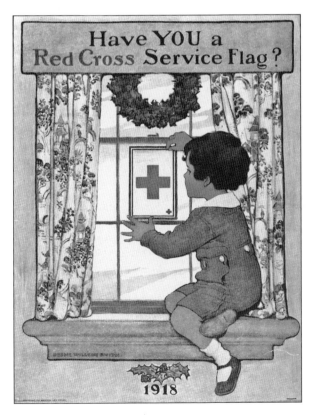

In 1918, this color advertisement by Jessie Willcox Smith titled "Have You a Red Cross Service Flag?" appeared in *Forbes*. While best known for her book and magazine illustrations, she also created advertisements like this as well as for Cream of Wheat and Campbell's Soup. In 2007, her painting *Little Mother*, 1922, sold at auction for $132,000. (Library of Congress, Prints and Photographs Division.)

In 1941, Caroline Pierson photographed professors Henry Snell and Samuel Murray at Katherine Maher's farm, the site of frequent staff picnics. Maher ran the school office. Snell, a painter, and Murray, a sculptor, each taught at the school for more than four decades. From 1886 to 1900, Murray and painter Thomas Eakins shared a studio at 1330 Chestnut Street. Murray made several bronze casts of poet and friend Walt Whitman, 2 of which are among 45 of his works are in the Hirshhorn Museum and Sculpture Garden in Washington, D.C.

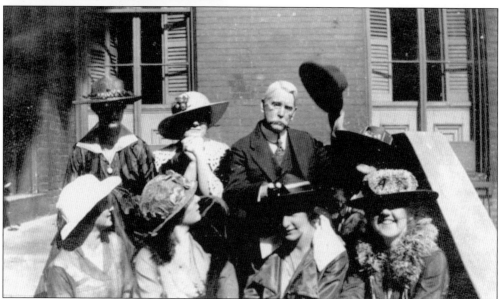

Henry Snell, a popular professor known as "Uncle Harry," forbid students to use the color black, asserting that it was too easy. He often took students on summer painting trips to St. Ives, the English seaside artist colony in Conwell, Snell's birthplace. This undated photograph shows Snell with students Felicia Waldo Howell, Paulette van Roekens, Marion Ohlenroth, Marian Wagner, and Anne Geyer. (James A. Michener Art Museum Library; gift of Anne Chestnut.)

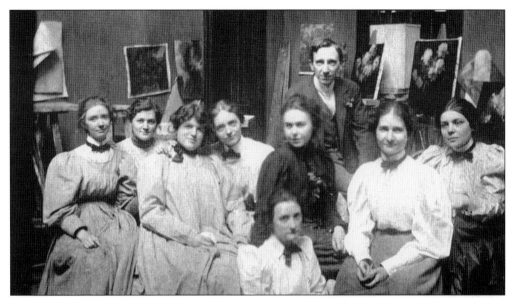

Elliott Daingerfield (1859–1932) is shown posing with students from his life-study class in 1895. He was also active in New York and North Carolina. Daingerfield later became noted for his mystical landscapes, especially after he visited the Grand Canyon in 1911. One painting generated by this western trip, *The Genius of the Canyon*, sold in 1920 for an astonishing $15,000, which, at the time, may have been the highest paid in the United States for the work of a living artist.

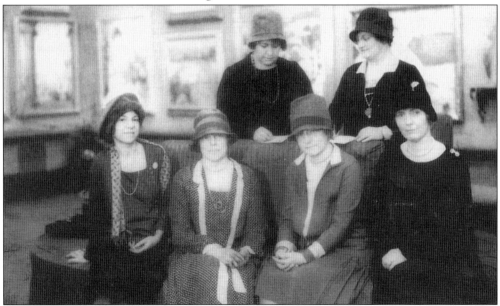

The Philadelphia Ten was a group of women artists practicing and exhibiting together in between 1917 and 1945. Seven of the original Philadelphia Ten graduated from the Philadelphia School of Design for Women between 1890 and 1915. In 1998, as part of the sesquicentennial celebration of the college, the Galleries at Moore held a retrospective of their work. This photograph by Jeannie Nuting shows group members at the Art Club of Philadelphia exhibition in 1928. (Emile Branson Manzler.)

Mary-Russell Ferrell Colton—a 1908 alumna and one of the original cofounders of the Philadelphia Ten—was not only an accomplished artist but also a cultural pioneer. Following a move to the Southwest in 1928, Colton and her husband founded the Museum of Northern Arizona, where she served as curator and an active supporter of Hopi Indian craft. In 1981, Colton was inducted into the Arizona Women's Hall of Fame. (Museum of Northern Arizona.)

Pictured here is *Grampy Reflects*, 1923, oil on canvas by Isabel Branson Cartwright, a 1906 Moore alumna and member of the Philadelphia Ten (1917–1945). In 1924, this painting was the first student work to be purchased by Moore, then known as the Philadelphia School of Design for Women.

Nancy Maybin Ferguson is shown here around 1900. Ferguson attended the Philadelphia School of Design for Women (1892–1895 and 1899–1904). A member of the Philadelphia Ten (1923–1927 and 1930–1938), Ferguson's work featured scenes of Philadelphia and Provincetown, Massachusetts, the two locations where she spent most of her life. Well regarded by colleagues and critics, her work was in the collection of Dr. Albert C. Barnes, the founder of the famed Barnes Foundation.

Above is *The Old Rittenhouse Mansion in Fairmount Park*, from around 1928, oil on canvas by Nancy Maybin Ferguson '04. Ferguson's paintings of scenes in and around Philadelphia were frequently exhibited with the Philadelphia Ten. The houses in Fairmount Park, not far from her home on Tulpehocken Street in Philadelphia's Germantown area, were among her favorite subjects, along with the scenes and people of Rittenhouse Square.

Painter Theresa Bernstein graduated in 1911 and settled in New York. An original member of the Philadelphia Ten painters, her career spanned more than 80 years. Wishing to be judged on the quality of her work, not on her sex, she signed her work T. Bernstein, a practice followed by other women artists at the time. Bernstein's style, not typical of the Philadelphia Ten, is closer to the Ashcan school. In 1998, Bernstein, aged 107, poses here with curator Page Talbott at the opening reception of Moore's sesquicentennial exhibition the Philadelphia Ten.

Textile design graduate Edna Acker Leonhardt '23, had a wide-ranging impact on manufacturing. Winner of the school's Widener European Fellowship, Leonhardt found inspiration in a lifelong love of travel. A King Tut–inspired tapestry she designed is credited with reversing the fortunes of a struggling Philadelphia textile mill. It was so popular that the mill had to hire 300 additional employees to keep up with production. Leonhardt later taught at the school and was the first woman to design fabric for the interior of an automobile.

Esther Richards was the first woman designer of an American postage stamp. Richards designed this 10¢ stamp, first issued on October 8, 1934, one of a series celebrating the national parks. Richards's engraving shows a view of Mount Le Conte in Great Smoky Mountains National Park. Richards, who graduated from the school in 1921 with a degree in illustration, sent Harriet Sartain a first-day cover of the stamp. (U.S. Postal Museum.)

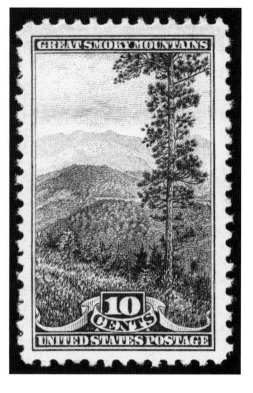

Anna Russell became the first African American graduate of the school in 1925. A distinguished student, Russell won awards for wallpaper and carpet designs; she enjoyed a successful career as a textile and graphic designer. In 1987, Russell recalled Harriet Sartain's advice: "She always told me I could do anything I wanted to do." In World War II, Russell became the first Philadelphia black woman to join the Women's Army Auxiliary Corps, where she worked as a graphic artist. (The African American Museum in Philadelphia.)

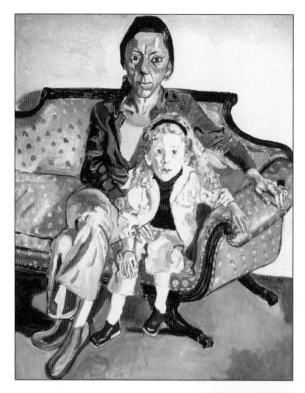

This 1973 oil painting by Alice Neel '25, *Linda Nochlin and Daisy*, depicts art historian and feminist leader Linda Nochlin with her daughter. Neel's intimate mother-daughter portrait captured Nochlin just two years after her groundbreaking essay "Why Have There Been No Great Women Artists?" was published in *Art News*. Nochlin was later honored as one of Moore's Visionary Women in 2007. (Museum of Fine Arts, Boston.)

Alice Neel entered the school on scholarship in 1921. This early painting by Neel was done while she was a student at the Philadelphia School of Design for Women. The painting appeared in the school catalog for 1925–1926, the year Neel graduated. Neel's obituary in the *New York Times* called her an unconventional portraitist who was once described as "the quintessential Bohemian."

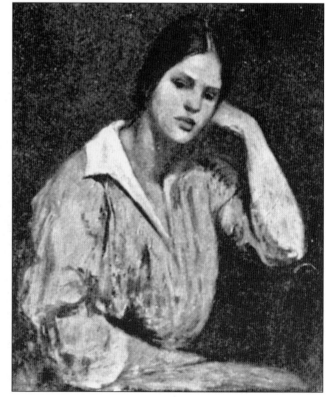

This photograph was taken at the 1984 commencement at which several of Moore's professors emeriti were present. Pictured from left to right are (first row) former drawing and painting professor Paulette van Roekens '15, painting professor Arthur Meltzer, and advertising professor Libbie Lovett Stewart; (second row) advertising professor Vincent Faralli, art history professor Alden Wicks, who gave the commencement address that year, and painting and printmaking professor Leonard Nelson.

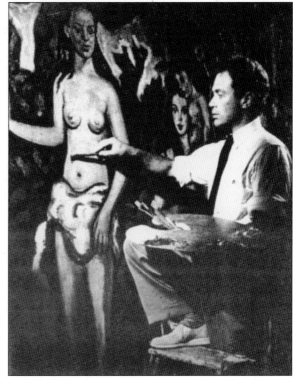

The Russian-born artist Doyla Goutman joined the faculty in 1952 after an earlier career as an art director for Paramount Studios. This photograph captures Goutman as he paints "phony Gauguins" for the movie *The Moon and Sixpence* (1942). He taught painting at the college for 33 years. His collections hang in the White House as well as the Pennsylvania Academy of the Fine Arts, where he earned his master of fine arts degree.

Edith Jaffy Kaplan '39 was the first woman art director for an American advertising agency. At N. W. Ayer and Son, where she worked from 1942 to 1953, she won gold medals on accounts such as Plymouth automobiles and Sealtest ice cream. Jaffy also taught at the Philadelphia College of Art (now the University of the Arts) and lectured at Moore. She received the Distinguished Alumnae Award in 1973.

Louise Zimmerman Stahl '42 taught color theory at Moore for over 50 years. After graduation, Stahl was at the Curtis Publishing Company for several years working with inks and paper. She joined the Moore faculty in 1947, revolutionizing the teaching of color by incorporating German Bauhaus color theory into her class. The exhibition Louise Zimmerman Stahl: Theory into Practice was held in March 1990 at the Galleries at Moore. The college dedicated Louise Zimmerman Stahl Residence Hall in 2005 to honor the beloved alumna and faculty member.

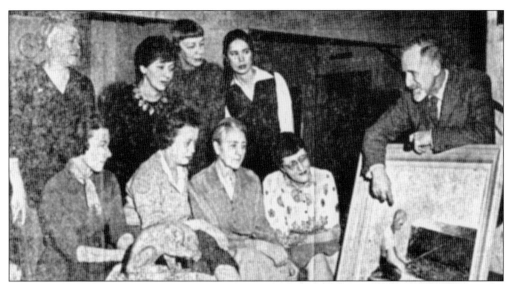

The school's galleries first gained visibility under the direction of Diane Vanderlip and Helen Drutt English. In 1962, Women in Art was the Philadelphia's first all-woman annual and included the work of more than 100 area women artists. This photograph from the *Evening Bulletin* includes exhibitors Patricia Mangione, Ethel Moore, faculty member Beatrice Fenton, Elizabeth Wolpert, Elizabeth Reinsel, Tana Hoban '38, Edna Andrade, and Elizabeth Osborne. Holding the painting is painter-teacher Leonard Nelson, chairman of the show. Hoban, a 1938 illustration major, went on to author and illustrate more than 100 books.

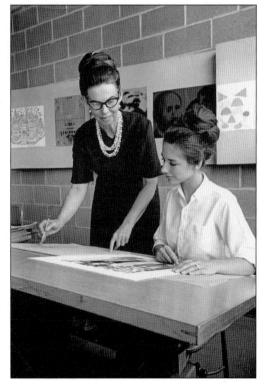

In this 1965 photograph, Libbie Lovett Stewart, a longtime instructor of advertising art, helps a student with her illustration. Born in Salem, Ohio, Stewart was educated at Philadelphia College of Art (now the University of the Arts). She was one of few women whose work appeared on the cover of the *Saturday Evening Post* and the first woman to work as an artist at Philadelphia's N. W. Ayer and Son, the first advertising agency in the United States, founded in 1869.

Twins Ida "Libby" Liebowitz Dengrove and Freda Liebowitz Reiter graduated in 1940 with degrees in illustration and advertising art. Both became courtroom illustrators: Ida at NBC and Freda at ABC. Their sketches were seen worldwide. Ida was the first woman to receive two Emmys from the National Academy of Television Arts and Sciences for her courtroom sketches of the Son of Sam and Murder at the Met trials. She also sketched such notable figures as John Lennon, Mick Jagger, and Ariel Sharon. Freda's work included coverage of the Watergate trials.

Ida Libby Dengrove graduated in '40 with a degree in illustration and advertising art.

Author and artist Miriam Troop '39 was the only civilian woman sent to the Korean war zones. In 1953, she traveled to Korea with the Society of Illustrators, who volunteered to make drawings of servicemen and servicewomen. Her illustrations appeared in *Fortune*, the *New York Times*, and on the covers of the *Saturday Evening Post*. This portrait of Al Hirschfeld was purchased by the National Portrait Gallery in 1999. Each year, the college awards a portrait prize in her name.

In this 1974 photograph, board member Rose S. Hirschorn presents artist Helen Frankenthaler with an honorary degree. Claus Oldenburg and Philadelphia Museum of Art curator Elsie McGarvey also received honorary degrees that year. Two years later, Oldenburg's monumental 45-foot, 10-ton steel *Clothespin* was installed in front of the Center Square Building at 1500 Market Street. The iconographic public sculpture was Oldenburg's reaction to the ornate 19th-century-style Philadelphia City Hall.

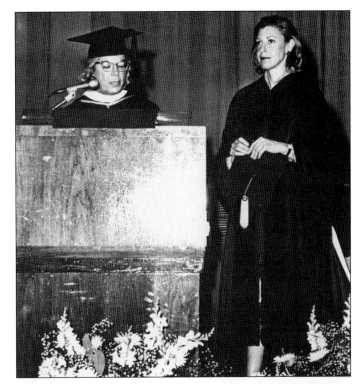

Helen Abby Jay Bershad graduated in 1956 with a dual major in illustration and painting. Influenced by the abstract expressionist movement, Bershad holds the distinction of being the school's first abstract painter. Known for her intense use of color, her work has been exhibited in galleries across the United States, including solo exhibitions at the Woodmere Museum of Art and Marian Locks Gallery.

Jane Zimmerman Walentas, a 1966 Moore alumna in advertising design, is seen here restoring a carousel figure. Walentas, who has always been fascinated with carousel art, began to hand restore the 1922 carousel in the 1980s, when she and her real-estate-developer husband, David, bought the carousel with the intention of eventually giving it a new home in the Fulton Landing waterfront area in Brooklyn, New York, now known as Dumbo.

Internationally acclaimed fashion designer Adrienne Toth Vittadini graduated in 1966. Known for her collections of women's knitwear, Vittadini won the 1984 Coty Award for Best Fashion Designer. An article in the *Philadelphia Inquirer* quotes Vittadini as having received "tremendous encouragement from all of my professors — and my classmates" while at the college. In a 1985 interview for *Moore News*, Vittadini told the college, "Philadelphia has always been a very, very artsy, creative city." She credits her senior internship at Wanamaker's with helping her clarify her career goals.

Carol Porter graduated in 1971 with a degree in advertising design. An award-winning graphic designer with the *Washington Post*, Porter cited the small environment and the personal interest of faculty member Libbie Lovett Stewart for her being well prepared for the working world. Porter served on the college board in the 1990s, and in 2002, she received the Distinguished Alumnae Award.

Karen Daroff '70 is principal of Daroff Design, Inc. (DDI), one of the nation's leading interior architecture firms. Daroff founded the firm in 1973, just three years after receiving her bachelor of fine arts degree. Clients include the Smithsonian Institution, Disney Development Corporation, the Franklin Institute's Science Store, Comcast's corporate headquarters, and the Levy Gallery at Moore. Daroff is pictured with Moore alumna Kate Rohrer '05, one of 60 designers and employees at DDI.

Philadelphia-based ceramicist Jill Bonovitz '74 is a cofounder of the Foundation for Self-Taught American Artists and, along with Janice Merendino '74, a founding member of the Clay Studio in Philadelphia. In 1999, Bonovitz had a solo show, 100 Teacups, at the Galleries at Moore. She consistently works around the theme of the vessel. In 1999, Bonovitz was awarded a Leeway Foundation Grant for Excellence.

Pulitzer Prize–winning photographer Sharon Wohlmuth is a 1975 graduate with a degree in photography. Wohlmuth is known for her best-selling books that she cowrote with author Carol Saline. The books include *Sisters, Mothers and Daughters*, and *Best Friends*. Wohlmuth is shown here at a book signing at the college in 1998 with acting president Mary-Linda Armacost holding *Best Friends* and with professor emerita Judith Harold-Steinhauser, one of Wohlmuth's mentors.

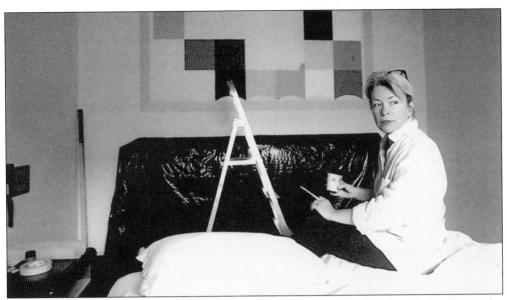

In 1999, Massimo Franchi photographed New York–based artist Mary Judge '75 at the Hotel Albronoz as she prepared for an exhibition in Spoletto, Italy. Judge has exhibited extensively in the United States and abroad. Judge taught at Moore for 14 years. Through her company, Mary Judge Designs, she also manufactures and distributes her olive-oil dipping dishes. The dishes have been featured in *Wine Spectator*, *British Elle Decor*, and *InStyle* and are a popular item for sale in the Art Shop at Moore.

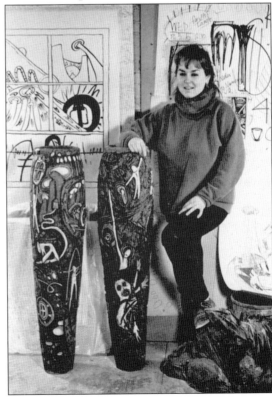

Pictured here during her college days, renowned artist Kathy Butterly graduated from Moore in 1986 with a bachelor of fine arts degree in ceramics. Butterly's now-trademark style features small-scale, abstract, anthropomorphic ceramics, widely praised for combining sculptural and textural complexity with irreverence and wit. Butterly has had numerous exhibitions throughout the United States and abroad and has had her work featured in the *New York Times*, *Art & Antiques*, and *Ceramics: Art and Perception* magazines.

93

New York–based video and installation artist Janet Biggs is a 1981 fine arts major. Her early video work often used the image of the horse to examine the way society constructs gender; other themes include spectatorship, pharmaceuticals, and aging. In a review published in the *New York Times*, Dominick Lombardi wrote, "Janet Biggs's video installation *Ritalin* (2000) is an extraordinary commentary on the controlling effect of drugs on creativity driven by adrenaline."

Emily Bittenbender graduated in 1989 with a degree in interior design. She became the first female general contractor registered with the Carpenter's Union. In 2003, Bittenbender received a Philadelphia Business Journal Woman of Achievement Award for her role as vice president of construction and design for the National Constitution Center's $137.5 million museum project. The center opened in Philadelphia on July 4, 2003. She heads Bittenbender Construction LP, the only woman-owned construction company in Philadelphia.

Five

THE STUDENT EXPERIENCE

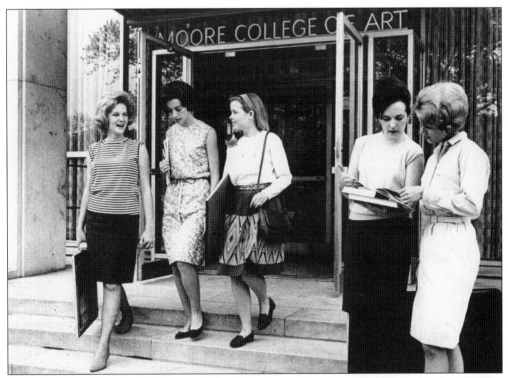

The 1919 catalog boasts of having graduated "more than 11,000 women trained in the fine and applied arts." At the time of this photograph, soon after the move to the Benjamin Franklin Parkway in 1959, the number must have reached nearly 20,000. Throughout the school's history, the focus on education for careers in art and design and the rigors of studio classes attracted serious students. The discipline and long hours of study, however, have not prevented students from pursuing political activism and social interests. In 1862, regulations forbade students from "entering into any conversation unconnected with her occupation during school hours." In 1929, when the school introduced residential facilities, students dressed for dinner. By the 1960s, rules had relaxed. The social life of students over the years included costume balls, tea parties, fine arts debates, glee clubs, and other activities.

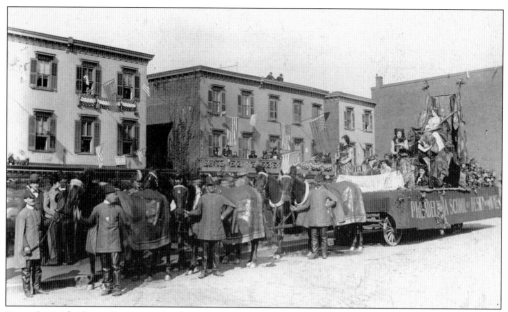

Dated 1916, this photograph shows a horse-drawn float by the Philadelphia School of Design for Women. It is not certain what parade this appeared in. In 1936, professors Lucile Howard and F. Chantry Coe were contracted to do the costumes for the Connor String Band for the Mummer's Day parade. Students in the Fashion Illustration Department of the school assisted.

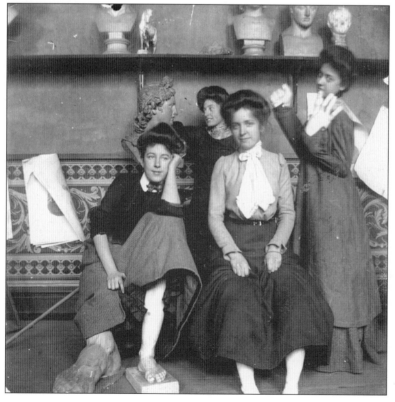

Students have fun with the plaster casts around 1898. Pictured are Mabel Horn, Miss Hall, and Mabel Herbert. The woman with the bust remains unidentified. The school's extensive collection of plaster casts was given to the Pennsylvania Academy of the Fine Arts when Moore moved to the Benjamin Franklin Parkway in 1959.

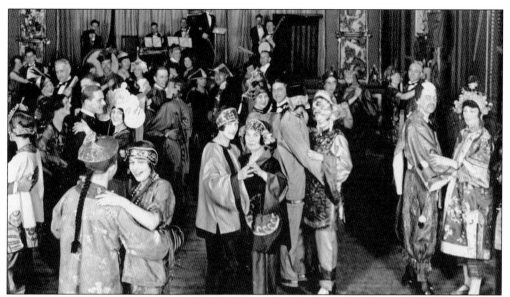

In the 1920s, 1930s, and 1940s, the alumnae association hosted themed costume balls to raise funds for the school. The balls were elaborate, with the school transformed into an ephemeral fairy tale or distant land. Students and friends dance here in the miniature theater at Broad and Master Streets in this 1924 photograph. College professor Arthur Meltzer designed the beautiful Chinese-themed murals and executed with the students' help. Impressed by Meltzer's murals, Judge Edwin O. Lewis commissioned murals for his home.

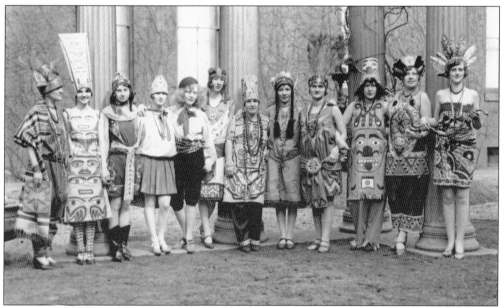

This photograph in the courtyard at Broad and Master Streets shows students displaying their costumes for the 1927 Aztec Ball. Attendees were requested to wear costumes to participate in the 11:00 p.m. processional, after which supper would be served. This photograph was likely taken before or after the ball, as the courtyard would have been dark during the dance itself, which ran from 9:00 p.m. to 3:00 a.m.

For the biennial ball by the college alumnae association, students were asked to help advertise the event by designing colorful posters and handbills decorated in the chosen theme. These posters advertise "the Fete of the Jade Buddha." Themes in subsequent years included "Discover America with Columbus and Cortez," "One Arabian Night," and "A Mediterranean Cruise with Marco Polo." These themes reflected popular interest at the time in "exotic" cultures like Egypt, Asia, and Mexico. Some themes took their inspiration from the theme of the world fairs of the era. The school had a history of exhibiting student work in these expositions and won numerous awards. At the South Carolina Interstate and West Indian Exposition in Charleston in 1902, the Louisiana Purchase Exposition in St. Louis in 1904, and the Philadelphia Sesquicentennial Exposition in 1926, the Philadelphia School of Design for Women took gold medals. The medal in St. Louis was for its exhibition of work from the Design Department and from the normal art course. Later this exhibit was taken to Washington, where it became part of the permanent exhibition of the U.S. Department of Education.

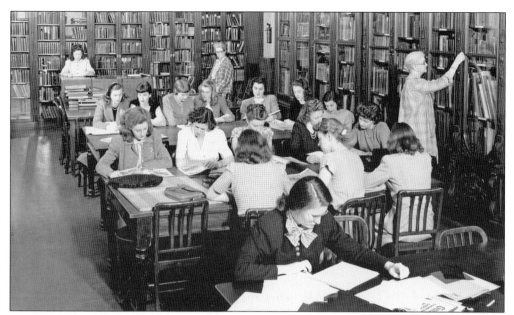

The library in the 1940s was presided over by Virginia L. Martin, shown on the far right retrieving a book from the glass-fronted cabinets. The students appear extremely studious, each engrossed in her volume. The scene is perhaps that of an entire class brought to the library to research information for a class project.

The staff cat, Blackie, lived at Broad and Master Streets and belonged to the Coyles, a husband-and-wife pair who served the school from 1900 to 1940. The Coyles lived in the building, and their children would use the back entrance to get to their lodgings. Students consulted Mary Coyle if they were sick, and she ran the school store. Her husband, Hugh, took care of the building and acted as janitor.

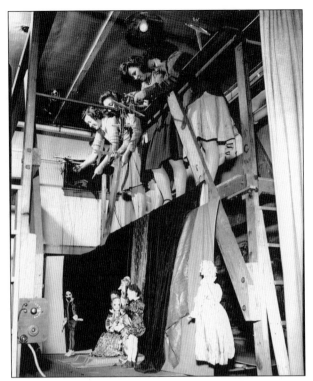

Puppetry class was required in the 1940s and 1950s. Each class chose a different play, produced the figures and the stages, and performed plays for their peers under the direction of Carolyn Person. The heads, hands, and feet of the puppets and marionettes were cast. This backstage scene is on the miniature stage in Lewis Hall at Broad and Master Streets. Lois Ini High and Mary Ruth Decker are two of the puppeteers at this 1941 performance.

The 1950s placard reads "Thieves Market," and this yearly sale in early December sponsored by the college alumnae offered many "steals." Teachers and students of the school produced goods for the sale, with the benefits going to fund a Christmas party for the less fortunate. Such activities allowed the public to see the talents of the students and offered an opportunity for faculty and staff to help the larger community.

Students in this publicity photograph from 1955 are enjoying the Race Street residences. Table tennis was very popular in the 1950s, and Moore's table saw a lot of action. The Moore pennant was a display of school spirit, as Moore has never had an athletic program.

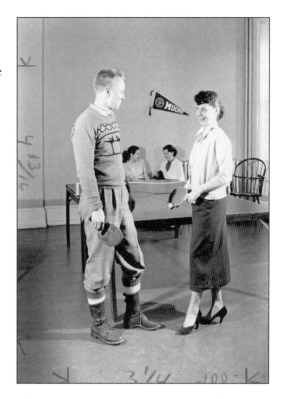

The Race Street dormitories were a home away from home. Women took advantage of the opportunity to socialize with like-minded artists, whether it was by eliciting feedback on a project or taking the time to relax. This cozy scene of knitting and ukulele playing would have been just the tonic after a long day of sketching, sculpting, and designing.

In the 1920s, the number of students applying from other states and abroad increased, and the school introduced residential services. Dining services were also offered at the 1921 Race Street residence halls that opened in 1929. At this time, students usually dressed for dinner and alumnae/student teas were held monthly. In 1925, the school also started to offer cafeteria services at the Broad and Master Streets location. A formal reception room was located through the doorway seen at the right.

In this undated photograph, one catches a glimpse of Moore's whimsical spirit. A top-hat-waving fashion design instructor is encircled by her class and their dress forms. Possibly taken in the 1960s from a window of the library, the students are embodying the idea of design. Note the modest placement of the gloves on the form in the lower right-hand corner.

In this 1966 photograph of Sartain Residence Hall, students pose for the yearbook. Located at 2039 Cherry Street, Sartain Residence Hall was formerly a YWCA. The building was possibly part of a purchase in the 1920s by Judge Edwin O. Lewis. It is named for the Sartain family, which provided leadership to the school over a 70-year span. Today Sartain Residence Hall houses 78 students and also has a commuter hotel.

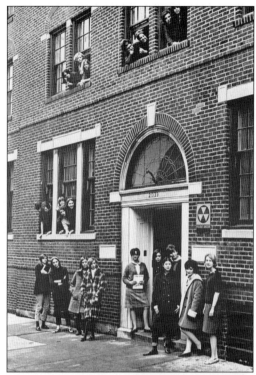

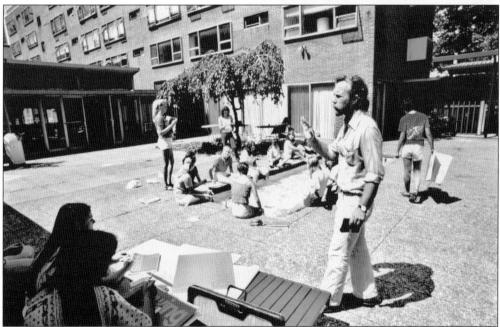

In 1970, the courtyard still included a wading pool, seen here in this photograph. College professor Frank Hyder is in the foreground. Professors often used the space to hold outdoor drawing classes. In 1987, the courtyard was altered to make way for the new Levy Gallery for the Arts in Philadelphia and the current Widener Memorial Foundation Gallery.

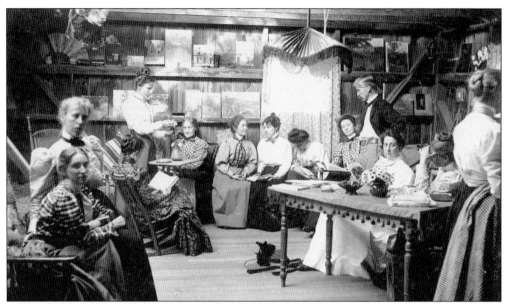

Travel has long been a part of the student experience at the school. College professor Henry Snell enjoyed painting from nature and often took students on painting trips both locally and abroad. This photograph taken in the early 1900s may include student Edith Howard '08, who studied with Snell. Howard, who was a member of the Philadelphia Ten, later became director of the Wilmington Academy of Art and the Delaware Art Center.

Moore offers a number of study-abroad courses to the Moore community every year. Here Mary Judge leads a group of students in a study-abroad trip to Italy in 1988. Pictured are Rosemarie Signore, Emily Bittenbender, Alice Strong, tour guide Nikolaus Eberan, instructor Mary Judge '75, Lynne Rudzewick, assistant professor Marian Pritchard, Maritere Irizzazry, Martha Graham, Karen Dinlon, Karen Fuegeman, Leslie Farber, Heather Wyckhoff, and Kim Cullen.

Interior design student Leasa Lewellen '88 appears here with her supervisor Lauren Hutton at her co-op (internship) at Space Design, Inc. Moore was the first school in Philadelphia to offer a co-op program so that students could have hands-on experience in the business world before graduation. Today bachelor of fine arts students in all majors are required to complete an internship.

Every fall, Moore's Basics Department hosts a trip to New York City for first-year and transfer students. Students visit New York's famous art museums, including the Metropolitan Museum of Art, the National Academy of Design, and the Whitney Museum of Art. They also explore the galleries and museums in Chelsea. For many of the students, the trip is their first experience visiting New York's renowned museums and galleries.

Dr. Amalia Mesa-Bains (far right) visited with Visionary Woman Award scholars at the fifth annual Visionary Woman Awards benefit gala in 2007. She spent the day prior to the awards as a visiting artist, meeting with individual students for critiques and conversing with students over meals. Honored with Mesa-Bains was Dr. Elizabeth A. Sackler, philanthropist, public historian, and founder of the Elizabeth A. Sackler Center for Feminist Art at the Brooklyn Museum.

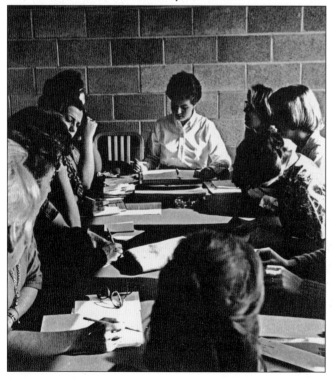

This photograph from the 1963 yearbook shows Moore's student council. Pictured are student council president Santa Maria, vice president Patricia Baldwin, recording secretary Paula Gainsborough, and treasurer Vera Carbo. Today Moore continues its commitment to preparing students for lifelong learning and leadership in the arts. The college has five on-campus leadership organizations, including student government, student orientation staff, residence life staff, the student judiciary committee, and Emerging Leaders in the Arts.

In 2000, then Moore sophomores Jamie Gordon and Melinda Spengler and junior Laurie Troppito joined more than 6,000 women from around the world to attend the Feminist Expo 2000 for Women's Empowerment, which was held that spring in Baltimore, Maryland. Pictured are Troppito '02 (left) and Gordon '03 (right) with feminist author and cofounder of *Ms. Magazine* Gloria Steinem (center), whom the students had the opportunity to meet at the conference.

Moore College of Art & Design student leaders were invited to hear presidential candidate Sen. Hillary Clinton (D-NY) speak at a campaign stop in Philadelphia on September 5, 2007. Clinton chatted with students, gave autographs, and posed for this photograph with the Moore students leaders, from left to right, Candice Roberts, Mandi Bell, Theresa McGlaughlin, Elisa Taylor, Alyssa Rittenhouse, Susan Falvey, and Sarah Mooney. The students presented Clinton with a T-shirt with the anonymous quotation "Sometimes the best man for the job is a woman."

Since the 1970s, the senior class has posed for a group photograph. It is traditional for the class to choose a cultural location. In this photograph from 2000, students pose on the steps of the Philadelphia Museum of Art. As part of the college's Culture in the Classroom program, Moore students are offered free membership to the museum.

Students in most majors participate in critiques of their work. Professional critiques add to the preparation for careers. Alumnae working in the field often return to offer professional advice and serve as guest critics. In this photograph, alumna Lisa Parmer-Ditty '91 (right) and instructor Linda Wisner (left) look over illustrations for Stevie Estibaliz Gamboa's senior collection in preparation for the 2007 spring fashion show. The alumnae network is also a strong presence at Moore's Locks Career Center.

108

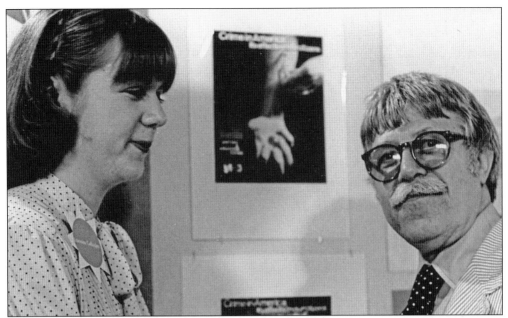

Linda Emerson '80 took this photograph at the school's annual Senior Show in 1979. Francesco DiSciullo, executive art director of the Michener Company, right, talks to Lorraine Galegher '79 at a special reception for the Art Directors Club of Philadelphia. As part of Moore's promise to educate women for careers in art and design, the Locks Career Center for Women in the Arts holds a VIP reception where the school's bachelor of fine arts graduates make their professional debut to potential employers, galleries, and buyers.

After graduating from Moore with a degree in fashion design, Alexandra De Yonge '02 has gone on to design for Lilly Pulitzer, Anna Sui, and Diane Von Furstenberg. De Yonge is shown here celebrating her win at Moore's Jumpstart Fashion Show with model Sam Lugiano wearing De Yonge's winning design, De Yonge's mother, and Moore president Dr. Happy Craven Fernandez. Jumpstart challenges students to create fashions in only a month.

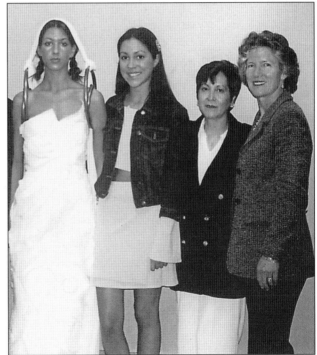

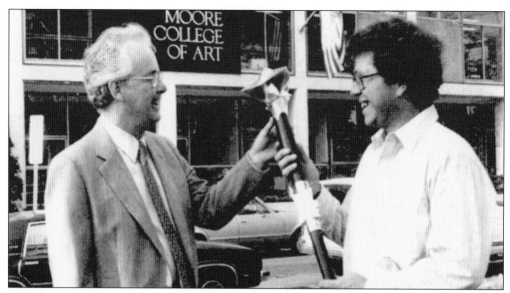

This ceremonial mace was designed by then Moore assistant professor Richard Posniak in 1985. Posniak designed and created the ceremonial mace for use during formal occasions, including the college's commencement ceremony. Posniak chose the floral design of the mace based on Moore College's strong history of floral forms. Of his design, Posniak explained, "The idea of the mace was to design something symbolic of femininity, embodied with resilience and flexibility."

In 1997–1998, Moore College celebrated its 150th anniversary with three events: a symposium, the Sartain Family and the Philadelphia Cultural Landscape, 1830–1930; the Student Show, exhibiting items from the school's archives; and a retrospective exhibition, the Philadelphia Ten. This photograph from the Student Show exhibition (1997) shows Moore president Barbara Gillette Price, far left, with, from left to right, students Danielle Harvey '98, Janine Wilusz '98, Christina Hansen '97, Randi Vanwy '97, and chair of the trustees (now chair emerita) Rochelle P. Levy '79.

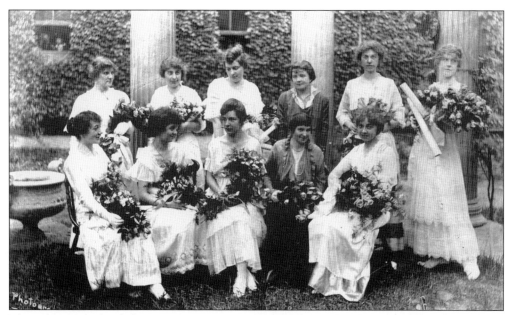

This photograph of the prize-winning graduates from the class of 1915 is one of the earliest graduation photographs in the college archives. Caps and gowns were not worn until the 1920s. From left to right are (first row) Dora Reece, Marion Oldham, Marion Wagner, Gladys Smith, and Grace Wells; (second row) Margaret Boericke, Laura Steigerwalt, H. Frances Kratz, Edith Burton, Dorothy Schell, and Anne Geyer.

This school processional was discovered in the archives. The processional was written in 1933; it is not clear when the processional ceased being used. The music was written by Letitia Radcliffe Harris and words by Philadelphia art critic Harvey Watts, who was a board member. The second stanza includes the line "Where Beauty stands impearled with Order, Symmetry, Design, Beloved of the Muses Nine."

Vincent Faralli, Advertising Arts Department head, created this academic seal in the 1960s. While no longer used today, it officially became the college emblem in 1963 and was used on the class ring, letterhead, and the 1963 yearbook cover. Note the ivy leaf, pen nib, and *M* insignia. Again the date 1844 (not 1848) appears as the founding year. This is incorrect and may originate with records of the Magdalen Society, which Sarah Peter became associated with in 1844.

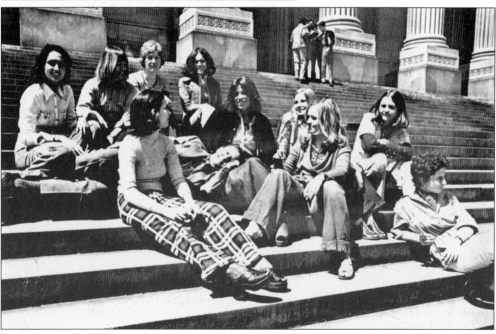

Each year a staff of seniors produces a yearbook for the graduating class. The yearbook staff in 1974 sat on the steps of the Franklin Institute, Moore's neighbor to the west, for this photograph. They include Ginny Blough, Marsha Sligsohn Braverman, Randy Lee Shulik, Janie Feldman Gross, Lynda Carol Chyhai, Gina Tottoroto, Susana Esclasans, Mimmi Whitney Lowry, Cheryl Mayes Warren, Joanne Adams, Bobbi Irwin, Jackie Hartman, and Janice Booth Petner.

Textile design professor Lewis Knauss, textile design major Laura Hart, and textile design professor Michael Olszewski model unique graduation garb at the 1991 commencement ceremonies. Each year at commencement, the textile design graduates and faculty have their own tradition of adding something to the graduation garb. (In 1991, Lowery Sims, curator of 20th-century art at the Metropolitan Museum of Art, and lithographer June Wayne were the honorary degree recipients.)

Moore nurtures women with talent in the visual arts, preparing them to flourish and become leaders in their fields. Upon graduation, students have access to an active alumnae association. The Locks Career Center for Women in the Arts provides students and alumnae with skills to launch successful careers. The 2007 graduates pictured here are, from left to right, (first row) Asma Iqbal, Andrea Felker, Cerina Burgos, Shavonne Cooper, and Inna Sidorova; (second row) Mariya Shekhtman, Lindsay Sabarese, Sarah Barton, and Johanna Tejada.

Alumnae activities include trips, workshops, and exhibitions. This photograph was taken on an alumnae trip to Washington, D.C., in 2007 and includes Doris Chorney, director of alumnae affairs, Marsha Nedelman '70, Janell Wysock '04, Martina Arnal '02, Kathleen Devine '86, Wendy Elliott-Pyle '84, Arlene Bilker Finston '56, Janie Feldman Gross '74, Jacqueline Foley Kochanowicz '89, Andrea Pinkowitz '73, Cate Chamberlain Wagoner '63, Jonel Becker Sofian '68, Doris R. Silk '48, Mindy Yavorsky Glassman '72, Deborah Larkin '70, Rochelle Levy '79, Frances Robertson Graham '66, Louise Curl Adams '62 '76, Joanne Adams '74, Shirley Hornstein Luber '47, Loretta Tryon-Pyle '87, Sheila Kantrow Quinlan '56, Katrina Mojzesz '92, and Gina Tottoroto Zegel '74.

In 1996, 192 Moore alumnae created "Transformation, Reflection, Connection: The Alumnae Quilt." The inspiration for the project originated with Judy Smith-Kressley '82, an accomplished fiber artist who underscored the unique storytelling aspects of the quilting process. The 10-foot-by-30-foot quilt, which recounts the varied alumnae educational experiences while at Moore, is on permanent public display on a wall adjacent to Wilson Gallery.

Six

THE IMPACT
ON PHILADELPHIA'S
CULTURAL LANDSCAPE

Pictured is the Evelyn Taylor Price Memorial Sundial sculpture, created by Philadelphia artist Beatrice Fenton in 1947. Fenton taught sculpture at the Moore from 1942 to 1953. A figurative sculptor and portraitist much recognized during her career, Fenton is known for whimsical works associated with water. Another of her representative works is *Narcissus*, which is at Salisbury University in Salisbury, Maryland.

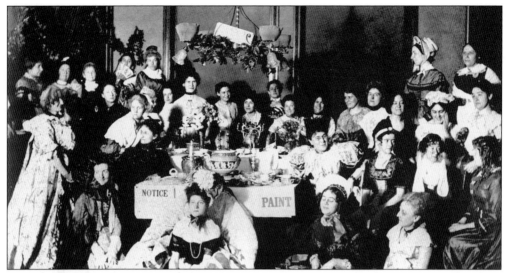

The Plastic Club was founded in 1897 as a professional women's arts organization. Founding members included Emily Sartain (principal 1886–1920) and alumna Alice Barber Stephens. Annually the club sponsored two exhibitions and the "Rabbit," a theatrical revue written and performed by members. This photograph from 1910 "Rabbit" shows Harriet Sartain standing with the black neckband and includes such distinguished artists as Stephens, Jessie Willcox Smith, Eleanor Plaisted Abbott, and Elizabeth Shippen Greene, all alumnae of the school. Active today, the club now accepts male members and is located at 247 South Camac Street.

Student Betty Crissman designed this poster for Wanamaker Toy Department in 1926. Harriet Sartain aggressively sought connections to local businesses to sponsor poster contests and partner with the school in other ways. Wanamaker and other department stores displayed original paintings and sculpture as window displays during Art Week, an annual event first began in 1922 by a group of artists affiliated with the Pennsylvania Academy of the Fine Arts. This poster also appeared in the 1926–1927 school catalog.

Samuel Fleisher, the Jewish philanthropist who founded the Graphic Sketch Club, is shown here costumed for the school's Chinese Ball. The club, now known as the Fleisher Art Memorial, was begun in 1898 to serve immigrant children in South Philadelphia. Harriet Sartain, who became dean of the school in 1920, was the first paid instructor Fleisher hired in 1905. Fleisher also served on the board of the Philadelphia School of Design for Women.

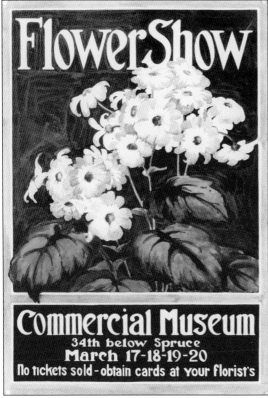

FlowerShow

Commercial Museum
34th below Spruce
March 17-18-19-20
No tickets sold - obtain cards at your florist's

The school would often take advantage of contests by turning them into assignments. Posters like this one for the flower show in 1925, the precursor to the Philadelphia Flower Show, were sometimes adopted and used as advertisements. The Commercial Museum has since been torn down, but the Philadelphia Flower Show is a preeminent gathering of floral and landscape designers each year, including M. R. Daniels '64. A prominent designer for such institutions as the Horticultural Society and the Rhododendron Society, Daniels became associated with the flower show in 1995.

Alice Neel '25 (right) poses with, from left to right, Ritta Redd and Jackie Curtis, the subjects of her dual portrait *Jackie Curtis and Ritta Redd* at her first solo exhibition at Moore College of Art & Design in 1971. Jackie Curtis was a famous transgendered film star, poet, and playwright and appeared in films by Andy Warhol, of whom Neel painted one of her most famous portraits.

Moore's location makes it easy for students to make the most of the cultural offerings in the city. The whole city becomes a classroom when students are taking photographs, sketching outside, or making detailed drawings in Philadelphia's many museums. In this 2005 photograph, students in college professor Janet Towbin's class draw specimens at the Academy of Natural Sciences, Moore's neighbor on the Benjamin Franklin Parkway.

BY DESIGN *New Visions for the Parkway*

July 12 – September 20, 2006

An exhibition celebrating the Parkway's evolution and showcasing dynamic plans for its future.

In the summer of 2007, the Galleries at Moore held a collaborative exhibition involving more than a dozen cultural and educational institutions on the Benjamin Franklin Parkway. By Design: New Visions for the Parkway examined the evolution of the Benjamin Franklin Parkway and showcased dynamic plans for its future. Images, site plans, designs, and architectural models brought to life the Benjamin Franklin Parkway, described as "America's Champs-Élysées." Annually the Benjamin Franklin Parkway draws three million visitors to the cultural and educational institutions that employ 2,000 people.

Moore senior fashion design major Heather Hinshaw demonstrates wheel throwing to children at the spring Parkway Fun Day event held on April 29, 2006. Students volunteer their time to support special activities and service projects. The event is another example of the collaborative nature of the Benjamin Franklin Parkway institutions.

119

Ob/De+Con(Struction)

This is a work by Austrian feminist artist Valie Export from Ob/De+Con(Struction), which was presented in January through February 2000 in the Goldie Paley Gallery. The first comprehensive exhibition of Export's work in the United States, the exhibition was part of the Galleries' International Discovery Series, which invites artists who, while significant, are not well known in North America. Other artists presented by the series include Artur Barrio, Terry Fox, and Jörg Immendorff.

Moore has brought people to the city for concerts, readings, lectures, and exhibitions. John Cage visited the college in 1979 and treated students to a live performance, and Eudora Welty graced the college with her presence in the 1960s. Here Brazilian artist Artur Barrio presents a toast with his coffee cup during a solo exhibition of his work: Actions after Actions, 2006, by the Goldie Paley Gallery. The Galleries at Moore provide a forum for exploring contemporary issues and ideas through the presentation of a diverse range of free exhibitions and public programs that offer both students and the Philadelphia community insights into the work of U.S. and international artists.

The Levy Gallery at Moore exhibits important work by emerging Philadelphia artists. Women to Watch: Photography in Philadelphia opened at the Galleries at Moore in October 2007. The exhibition was developed in conjunction with the National Museum of Women in the Arts (NMWA). In 2005, the college honored Wilhelmina Holladay, founder of NMWA, and artist Faith Ringgold with the Visionary Woman Award.

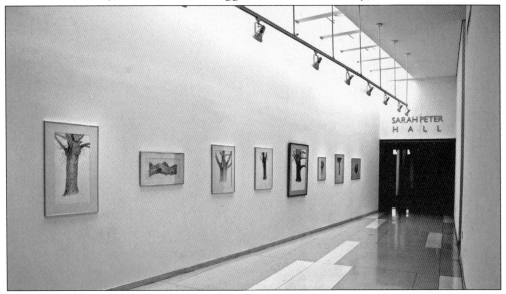

The Galleries at Moore include spaces where the public may view art by students, faculty, and alumnae. This photograph shows the Graham Gallery, named in honor of Frances Robertson Graham, an interior design major in the class of 1966, and her husband Bill Graham. The Graham Gallery was dedicated in the fall of 2006. Graham served as chair of the 160th anniversary celebration committee and is a member of the board of trustees.

121

The Art Shop at Moore, launched in 2002, sells original works of art by Moore students and alumnae. The shop offers visitors to the Benjamin Franklin Parkway a unique shopping experience and also educates students in the retail business. For the inauguration, alumnae contributed designs for playing cards and the college produced four decks of "Cards of Art" displaying the work of more than 200 alumnae.

The sculpture *Transduction* is installed under the supervision of, from left to right, chair and professor of fine arts Paul Hubbard, curator Marsha Moss, and artists Suzanne Reese Horovitz and Robert Roesch. Founded in 2003, Moore's Sculpture Park is located opposite the college, occupying the southern side of Aviator Park on the Benjamin Franklin Parkway. New work is installed annually. According to a Smithsonian Institution survey, Philadelphia has more public art than any other American city.

Pictured is *Frank Sinatra*, a mural by Diane Keller '71, located at Broad and Wharton Streets. Keller is one of many Moore students and alumnae who have contributed their talents to the Philadelphia Mural Arts Program (MAP), both as volunteers and professional artists over the years. Started in 1984, MAP has painted more than 2,700 murals throughout Philadelphia.

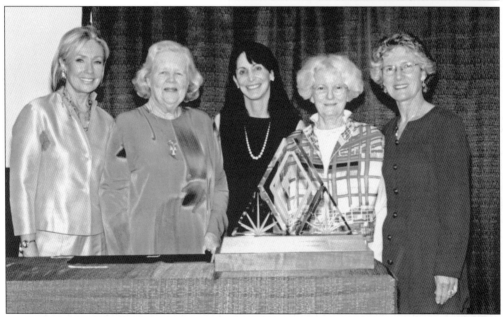

In 2003, the Visionary Woman Award celebrated three women with Philadelphia connections. Photographed at the gala awards ceremony that year are, from left to right, honoree and acclaimed Philadelphia-born fashion designer Adrienne Vittadini '66, chair of the board of trustees (now chair emerita) Penelope P. Wilson, honoree and founder of the renowned Philadelphia Mural Arts Program Jane Golden, honoree and internationally known architect Denise Scott Brown, and college president Happy Craven Fernandez.

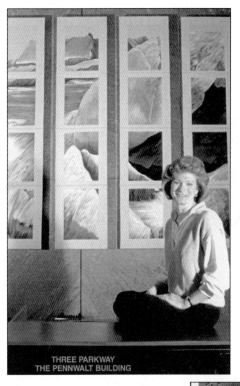

THREE PARKWAY
THE PENNWALT BUILDING

Work by Moore's faculty appears throughout Philadelphia. In 1986, Deborah Warner '69, textile design professor and chair, appeared on the college magazine cover with her wall hanging commissioned for the lobby of the Pennwalt Building. Other examples include Samuel Murray's bronze statue of Commodore John Barry near Independence Hall, Thomas Chimes's *Sleeping Woman* on Kelly Drive along the Schuylkill River, and Moe Brooker's *Everything is on Its Way to Somewhere* at the Kimmel Center.

Since 1983, Moore has worked collaboratively with the public schools on various art contests designed to promote art education. This 1986 *Philadelphia Inquirer* article on the holiday card art contest notes the contest attracted over 1,000 students. That year 48 winning designs (one from each age group) were reproduced and sold in department stores in the city. The card project enjoyed underwriting from such sponsors as Hunt Manufacturing Company, Provident National Bank, and the Sun Company. Proceeds from the sale of the cards funded scholarships to Moore's Young People's Workshop, now the Young Artists Workshop.

By Yuri Rozman

By Sagirtha Vivekananthan

By Jesse Lorenzo

By Heather McClain

Students send greetings with holiday art

By Edgar Williams

First you see Santa Claus, steering his sleigh toward the stratosphere as he calls for more speed from the Reindeer 8 in front of him.

Then the eye drops down and, behold, there is a panorama of the Philadelphia skyline. And suddenly it hits you that Yuri Rozman, 14, has accomplished something that all the shakers and movers and politicos of our city haven't been able to do in, lo, these many months.

He has freed City Hall Tower of scaffolding.

Yuri Rozman, see, is one of the winners of the 1986 Children's Holiday Greeting Card Contest, sponsored by the School District of Philadelphia and Moore College of Art. And smack in the middle of the illustration on his winning entry is City Hall Tower — and the statue of William Penn — sans that monstrosity of a spiderweb that started going up nearly two years ago.

Yesterday, as the winners of the four different grade-level categories gathered at the Gallery to help promote sales of the greeting cards, Rozman, a ninth grader at George Washington High School, Bustleton Avenue and Verree Road, observed that his depiction of a scaffold-free tower was "unintentional."

"I never really thought about it," he said. "I was working from a photograph of the skyline that must have been made some time ago. Maybe it's better this way. Maybe there will be people who buy the card to be reminded of what the tower used to look like."

People who, for whatever reason, buy the cards of any of the winners are important, inasmuch as all proceeds go toward scholarships for children from the city's public schools to attend the Young Artists' Workshop at Moore College. The program, in existence for more than 60 years, holds Saturday sessions during the school year, as well as a summer session.

More than 1,000 students, from grades one through 12 through-out the city, entered the competition, submitting designs, drawings or paintings. Each of the winners will receive $100 in cash and have a choice of two semesters or one summer session at the Young Artists' Workshop. Second- and third-place finishers may choose between two semesters or a summer session.

Rozman, whose painting was done in gouache, was the winner in the grades 7-9 category. The other winners were: grades 1-3, Jesse Lorenzo, 7, a second grader at the Brogy elementary school, 17th and Bigler Streets, grades 4-6, Sagirtha Vivekananthan, 9, in fourth grade at the Greenfield elementary school, 23d and Chestnut Streets, and grades 10-12, Heather McClain, 16, an 11th grader at the High School for the Creative and Performing Arts, 11th and Catharine Streets.

Two of the winners were born in other countries. Rozman came here with his family from Kiev in the Soviet Union when he was 7. Lorenzo, from the Philippines, spent five years in Hawaii and arrived in Philadelphia in July. He has had a noteworthy December: not only was he declared a contest winner but just Thursday he experienced snow for the first time in his life.

"Of course," he said with the assurance of one who has been around the block a time or two, "I had seen snow before, in the movies."

For his entry, Lorenzo did a crayon drawing of Santa Claus delivering a gift. Santa is beardless. Before you begin probing the artist's psyche, however, consider his explanation.

"This Santa Claus," he tells you, "is young."

Vivekananthan's card, done with Magic Marker, depicts four children of varying ages making a snowman. Definitively, but without ostentation, the artist shows each child as being from a different ethnic background from the others. It is an apt expression of the spirit of the season.

McClain's oil pastel painting shows a child, all bundled up, standing on snowy ground near a sparkling Christmas tree. McClain had a model: her sister Amanda, 7.

The cards, priced at $6 for a box of 12, are on sale just inside the Ninth Street entrance to the Center City store of Strawbridge & Clothier, as well as at Moore College of Art and at the gift shops of the Franklin Institute, the Central branch of the Free Library and St. Christopher's Hospital for Children.

At the Gallery to promote sales of their greeting-card art are (from left) Rozman, Vivekananthan, Lorenzo and McClain.

124

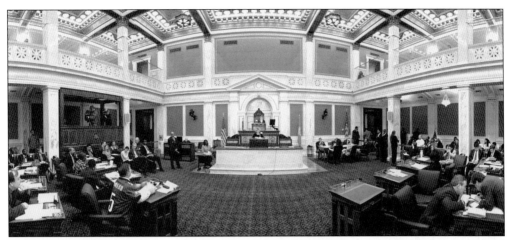

In 2005, interior designer Jennifer Nilsen '73, a principal of IEI Group, was retained by DPK&A Architects, LLP, to design the restoration of the flood-damaged city council chambers of Philadelphia City Hall. Designed by John McArthur Jr. with Thomas U. Walter and W. Bleddyn Powell, Philadelphia City Hall is one of America's great public buildings in the Second Empire style. The two-story 4,060-square-foot city chambers are ornately detailed with Georgian marble, gold leaf, decorative stenciling, and mosaic.

In September 2002, Moore students joined the Philadelphia Print Collaborative (now Philagrafika) and hundreds of other artist, students, and volunteers, to create a 260-foot print called "Broadstreet Broadside," setting the world's record for the longest print. The event inaugurated Image & Print: A Contemporary Conversation with History, a citywide print festival. Now Moore is one of the member organizations working with Philagrafika on Philagrafika 2010, a quadrennial international, contemporary art festival that celebrates the printed image.

Children from the After-School Art Program at Frederick Douglass Elementary School in North Philadelphia are pictured with Helen Cunningham, executive director of the Samuel S. Fels Fund at the spring celebration at Moore. With support from the Fels Fund, Moore has provided art education to children at Frederick Douglass since 2001. Moore also reaches out to underserved children through the Galleries, the Youth Art Month exhibition and contest every March, and scholarships to the Young Artists Workshop.

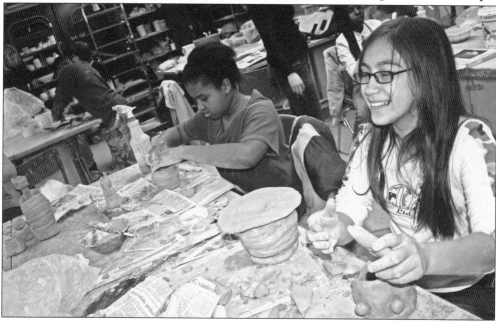

In 1921, the college first began offering art courses to young people through the Young People's Art Workshop (now Young Artists Workshop). The program received a $1 million endowment from the Annenberg Foundation in 2004. The grant created the Leonore Annenberg Young Artists Workshop Scholarship Fund. Currently the Young Artists Workshop serves 1,200 youths each year.

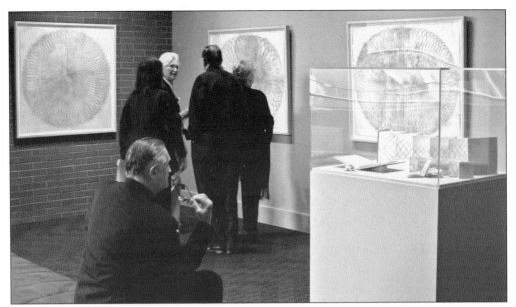

The Moore College Galleries at the Kimmel Center for the Performing Arts on Broad Street were created at the behest of an anonymous donor. The Kimmel Center opened in December 2001, with a gala led by Sir Elton John. Free and open to the public during Kimmel Center hours, the galleries, located on Tier 1, highlight both fine and design arts through rotating exhibitions of work by students, graduates, and faculty. In 2006, these visitors are pictured viewing work by Mary Judge '75. (Kimmel Center for the Performing Arts.)

In 2007, Moore College of Art & Design began a partnership with CBS3 and the CW Philly 57 to provide student exhibition space at the television stations' new broadcast center at 1555 Hamilton Street. Artwork by Moore bachelor of fine arts degree students is displayed year-round in prominent spaces at the headquarters, allowing thousands to view the student artwork. The work and information about the artists are also available on the CBS3 and Moore Web sites. The works photographed here are watercolor studies for textile designs.

ACROSS AMERICA, PEOPLE ARE DISCOVERING SOMETHING WONDERFUL. *THEIR HERITAGE.*

Arcadia Publishing is the leading local history publisher in the United States. With more than 3,000 titles in print and hundreds of new titles released every year, Arcadia has extensive specialized experience chronicling the history of communities and celebrating America's hidden stories, bringing to life the people, places, and events from the past. To discover the history of other communities across the nation, please visit:

www.arcadiapublishing.com

Customized search tools allow you to find regional history books about the town where you grew up, the cities where your friends and family live, the town where your parents met, or even that retirement spot you've been dreaming about.